PARANORMAL
LEICESTER

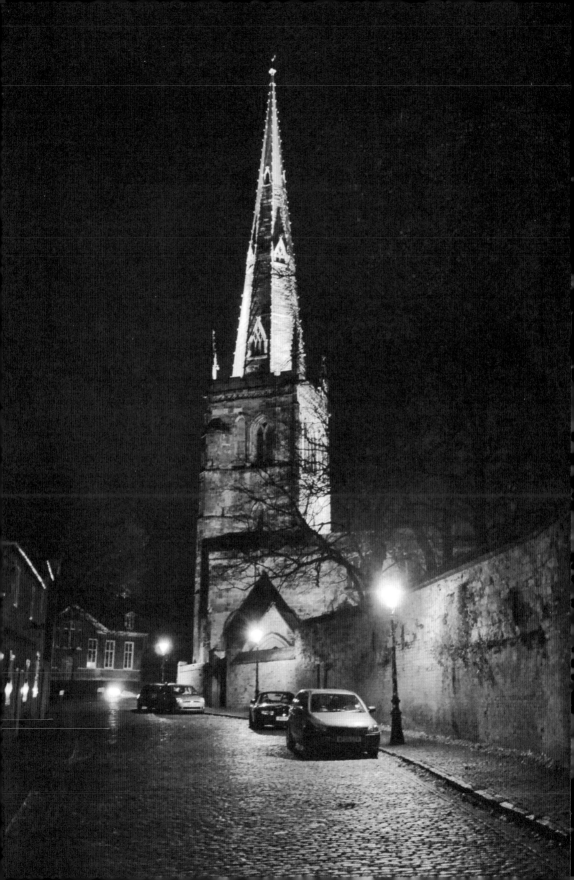

PARANORMAL
LEICESTER

STEPHEN BUTT

AMBERLEY

First published 2011

Amberley Publishing
The Hill, Stroud
Gloucestershire, GL5 4EP

www.amberley-books.com

British Library Cataloguing in Publication Data.
A catalogue record for this book is available from the British Library.

ISBN 978 1 84868 752 3

Typesetting and Origination by Amberley Publishing.
Printed in Great Britain.

Contents

Introduction 7

1 Hauntings, Happenings and History 11

2 Myth and Superstition 21

3 The Belgrave Triangle 27

4 Black Annis – Evil Personified 39

5 Robert James Lees – Man of the Mists 45

6 The Epic House Haunting 63

7 A Ghost Walk Through the Old Town 71

Acknowledgements and References 91

List of Illustrations 93

Introduction

Even an attempt at a definition of the word 'paranormal' is difficult. The prefix *para* has both Latin and Greek roots, but it is the Greek language that provides the best meaning. The suffix means 'beside' or 'alongside' or 'beyond'. The word 'paranormal' was invented during or just after the First World War, and its generally agreed meaning is that it describes events that are beyond, outside of or contrary to current scientific concepts.

Of course, this sort of definition can lead to difficulties in approaching the subject in a serious and logical way. By definition, anything 'paranormal' cannot conform to conventional expectations, so its existence cannot be confirmed by scientific methodology because, if it was, it could not be 'paranormal'. If a paranormal event could be recorded and measured using instruments that were designed to measure the physical and the 'normal', then the paranormal entity must be as physical and as 'real' as anything or anyone else.

However, despite this problem, the scientific study of paranormal phenomena abounds, with groups active in most major towns and cities, their work now watched regularly by millions of television viewers around the world.

As well as scientific analysis, a study of the history of a building or site in which paranormal activity has been reported often takes place as part of the process of detecting or explaining the paranormal. The argument is that if the manifestations cannot be measured by scientific instruments, then perhaps they can be explained by recourse to historical fact. So, in Leicester, as in many locations, haunting figures in Edwardian dress are most often observed in buildings of the Edwardian era, ghostly Roman soldiers march along the routes of Roman roads, and in most old hostelries, a former landlord or landlady reappears at some time to pull a few paranormal pints.

Making fun of something we cannot understand is a defence mechanism. Many ancient ceremonies involve creating physical representations of gods. Some pageants and rites exist primarily to help mankind come to terms with the paranormal. By walking around the neighbourhood on Halloween, dressed as witches and ghosts, we do not so much celebrate the concept of evil, but rather show our desire to face up to the doubts and fears that haunt us, no matter how deep-rooted those fears may be.

The inexplicable has always been with us. History is not merely a catalogue of events through time, their causes and consequences. History also records activities motivated by man's belief in the supernatural.

Some of the earliest structures built by man are those that respect events, which, at the time of construction, would have been beyond the 'normal'. One example is those structures that respect the alignment of the planets and the stars. History cannot prove or disprove the 'existence' of paranormal activity, but it can certainly record and interpret the ways in which mankind has always been influenced by such events.

Broadcasters, and others who work with sound engineering, talk about resonance. It is part of the study of how sound waves behave in a certain space and when they meet certain materials. It is a very physical, real and measurable phenomenon, but one that can make us feel different about a certain building or room. The English language has developed a secondary use for the word, so say that we may have a resonance with an opinion or a concept, using the word in a metaphorical context to describe people, ideas and events which are in agreement with each, or synchronous. In this context, having a certain resonance, or being 'in sync' is a positive attribute, but one that is all about feelings and attitudes rather than physical events.

Wyggeston's House in Leicester's Applegate, previously Highcross Street – the historic and very early route from the north to the south gates of the town – has a certain resonance. So too has the nearby Guildhall, and the Castle, and the Church of St Mary de Castro.

All buildings have resonant properties dictated by their physical size, shape and the materials used in their construction. The effect of resonance on human beings is very interesting. We need a certain amount of resonance – or echo – to enable our hearing to walk fully. Direct sound from another person or an object provides us with information; indirect sound, which has travelled farther from its sources to our ears by bouncing off various obstacles in its path, gives us special information and helps to place ourselves in some sort of physical context in our surroundings. There is also a phenomenon described by researchers as the 'precedence effect', whereby the first sound reaching our ears, before any indirect later sounds from the same source, provides our brains with all the information we need to locate its source.

Sound is a form of energy we cannot see. If the energy or sound wave that reaches our ears is vibrating at a speed faster than about 100 times every second, and slower than about fifteen thousand times, then most of us will hear it as a sound. Outside that range of frequencies, we may not hear it, though some animals will. If it is a very low frequency and very powerful, then we may feel it as a physical force, which can even move us.

Is there an analogy here with the vocabulary that is used in describing paranormal activity? When a building 'feels different' it is said to have a certain 'ambience'. Sound and other sensory information is vitally important to paranormal investigators. They listen. They watch. They attempt to record all forms of energy, including sound, light and changes in temperature. All these are physical things that can be recorded accurately. The paranormal investigators also talk about the 'atmosphere' of a location, and of feeling hot or cold, and, very often, activity may be sensed which cannot be recorded by the equipment available.

Science depends upon accurate measurement and recording. In the fields of astrophysics and astronomy, new stars and new galaxies are discovered whenever a new radio-telescope or array is built and activated. The stars were always there, but we have had no means of detecting them.

If the 'normal' is what we can sense with our body's mechanisms and detect with our scientific devices, then the paranormal is simply a term to describe anything and everything we cannot yet sense, detect or record. This does not mean that what we term the paranormal actually exists (and the term 'existence' deserves much more discussion and consideration); but neither does it prove that the paranormal does not exist, and is not very close to us, right now.

CHAPTER ONE

Hauntings, Happenings and History

Leicester is an old town, with a long history reaching back across two thousand years of human activity and experience. Historically, it is a very well-documented town. Leicester has a rich antiquarian record with plenty of other writings and documents that add to our knowledge of how our predecessors lived and, just as importantly, what they experienced during their lives.

The inhabitants of the town suffered persecution, events of great jubilation and celebration, and harsh military occupation. Over the centuries, they have experienced the rule of might, of law, of religion and of democracy, in times of prosperity and of hardship. If human emotions are capable of living on, to be expressed at some later time, then Leicester could be the perfect backdrop for so many interesting phenomena.

Not surprisingly for such an ancient place, Leicester has at least its fair share of stories relating to haunted buildings and other paranormal events, and of course many of these stories have thematic associations with its history and the experiences of its inhabitants.

The appearance of Roman soldiers in twentieth-century Leicester is a fascinating example of what might be a myth handed down over more than a century of oral tradition through many generations of pupils in one school building. The Wyggeston Hospital Boys School was built in Highcross Street in 1877 and, except for a brief period in the 1970s when it was empty for several years, it has always been a place of learning. After the Wyggeston School moved to its new premises, the Alderman Newton's School occupied the building, and then, and most recently, Leicester Grammar School.

Changing rooms were constructed below ground level, which partially extended beneath the playground at the rear of the buildings facing Leicester Cathedral. What is most interesting is that only a matter of a few years ago, a significant number of the younger students admitted that they were frightened to enter these rooms because, in their words, a Roman centurion 'was down there'.

Although most local people will know that the school is situated close to the centre of the former Roman settlement, it is doubtful whether many of the young students will have known that a Roman street lay either beneath or beside these

changing rooms, crossing their playground in a diagonal line. The precise route of the street was confirmed in archaeological excavations, in 2009, in preparation for the refurbishment of the school and its conversion into St Martins House for the Diocese of Leicester. This was some time after Leicester Grammar School had moved to their new site in Great Glen.

It is of course possible that the men who constructed the original buildings in the nineteenth century discovered the remains of the Roman road, could identify what they had unearthed, and that this discovery was passed on to the first pupils at the Wyggeston Boys School, to be repeated and embroidered down the generations and through three different schools. Some miscellaneous artefacts were found in one place by the contractors working on the St Martins House project, suggesting that the original workmen may have found them and deposited them in one corner of the building.

It is also possible that Roman material had been unearthed by the builders of the earlier Tudor hospital, which was built across the same site back in 1518. If this is the case, then possibly we have an oral tradition that has been handed down through almost five hundred years, keeping alive the possibility of 'seeing' a Roman centurion on the march.

At the heart of almost all ghost stories is a building of considerable antiquity. Traditionally, buildings that represent a past era are those that tend to attract notoriety or a reputation for being haunted. Fascinatingly, and no doubt of great value to those who are tasked to promote and publicise them, no less than six of Leicester's museums and public buildings have a history of haunting.

In Leicester, the medieval Guildhall is high up on the 'most haunted' scale. It is a building that speaks loudly of its past. Its obvious antiquity and its physical structure, the old wooden beams, creaking uneven staircases and dark, dank cells all provide a colourful and ideal backdrop for the occurrence of paranormal events. Leicester has many such buildings that seem almost 'designed' for the purpose of being haunted.

The Guildhall certainly deserves to hold the title of being the city's most haunted building, with no less than five reported resident ghosts. On many occasions, staff and police have been called out during the hours of darkness to respond to burglar alarms, triggered by an inexplicable presence.

The most regular visitor is known as the 'White Lady' and she makes her presence known by moving the heavy Tudor furniture around the library, and by opening various doors after they have been locked. A large lectern Bible, kept on display on a table in the centre of the library, would be found open at a specific page even though staff had closed it on the previous evening.

Heavy footsteps have been heard crossing the main entrance to the constable's cottage, which is located in the wing of the building furthest away from Guildhall Lane and near to the boundary wall with the Wyggeston premises. This is believed to be the ghost of one of the police officers who were based in the building during the Victorian period. Footsteps have also been heard above the ceiling, which have also been connected to the former presence of the Victorian police force. The officers slept in the roof space, and the pegs for their uniforms can still be seen today.

A psychic researcher who visited the site reported that she could 'see' a cavalier-type character in the Great Hall and a phantom dog in the courtyard, though no record of either of these phenomena has been recorded by anyone else.

In 2004, the popular and sometimes controversial programme *Most Haunted*, which is produced by Living Television, visited the Guildhall. The programme claimed that their resident mediums, Derek Acorah and David Wells, sensed immediately the presence of Victorian pickpockets, policemen, and a presence in the area of the cells which they could only describe as 'evil'.

The television team also heard footsteps in the roof space above the library on the first floor, as well as two or more men fighting a duel, apparently, in the Great Hall which is the earliest part of the ensemble of buildings. Many of the crew, who were veterans of visits to so-called haunted establishments across the country, allegedly felt physically unwell in the area of the cells.

However, it has also to be said that regular holiday events for children are held in the same area, based on the theme of ghosts and hauntings, and there have to date been no reports to the media of any child or parent feeling ill during one of these sessions.

Almost exactly five hundred years seperate the earliest part of the Guildhall and the Abbey Pumping Station in Corporation Road – a fine example of Victorian industrial engineering and design. This is said to be haunted by the ghost of Robert Richardson. Opened in 1891, the station was a landmark in the improvement of public health

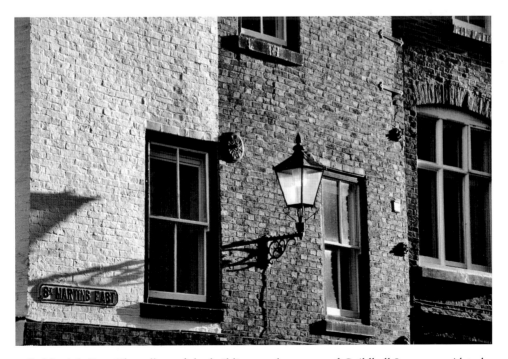

1 St Martin's East. The cellars of the building on the corner of Guildhall Lane are said to be haunted.

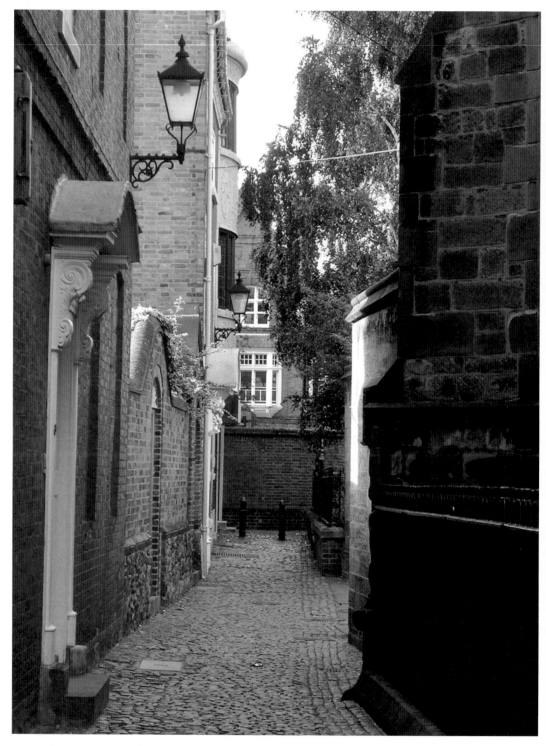

2 St Martin's East, looking past the former Provost's house towards Peacock Lane and the Greyfriars area.

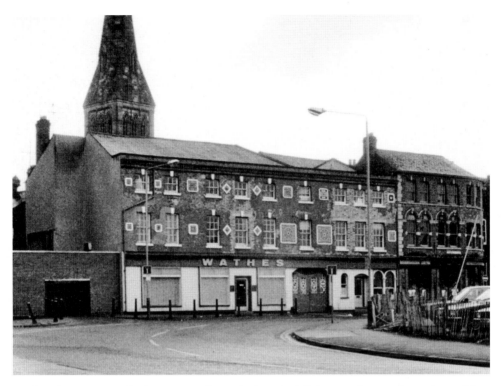

3 The showrooms of Thomas Herbert Wathes in Highcross Street, formerly a Cigar Manufactory and now the site of BBC Radio Leicester's studios.

in the town, its four great beam engines, built locally by the Gimson Company, pounding away by day and by night to remove Leicester's sewage to treatment works at Beaumont Leys. It is a grand building on a grand scale and its technology was cutting-edge at the time. Richardson was an engineer who worked on the construction and outfitting of the building. In 1890. he fell to his death from the top balcony of the pump house into the engine room. A cross with an inscription was placed on the basement wall by his friends and workmates.

Other paranormal events have taken place in the same building, mainly near to the engine house. Discounting the fact that the massive beam engines and the boilers that supply them will always be producing some noises as they expand and contract, in a similar way to central heating radiators in a family house, strange noises have been heard on many occasions, usually late in the evening when the museum is about to be secured for the night. Some former staff members have said they have been quite shaken emotionally by these experiences.

The figure of a man in Elizabethan-style costume has been seen in the Newarke Houses Museum. The man appears from the wooden panelling in the Gimson Room and disappears through an adjacent wall. A mysterious shadow, with a human form, has also been seen in the area. On several occasions, a member of staff has stepped to one side to allow a figure through, only to realise that no one was present.

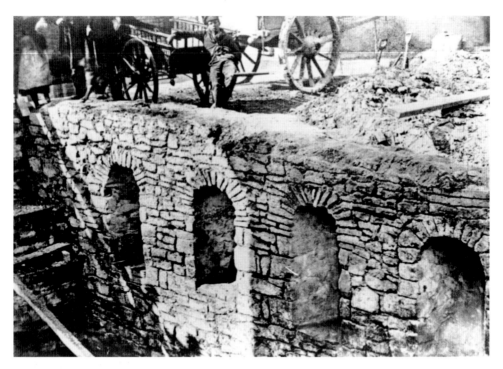

4 The undercroft beneath the BBC studios at the rear of 9 St Nicholas Place, photographed in 1861.

A figure in a long, dark cloak has been seen at the top of the main staircase, walking towards the window. This particular figure is mainly seen in Wyggeston's Chantry House, the oldest area of the museum. When repairs were being made in the building, a postcard holder rotated on its own, throwing all of the cards out on the floor.

The figure of an Edwardian or Georgian boy has been seen in Wyggeston's House in Applegate, although he is usually heard rather than seen. The sound of a ball bouncing down the stairs has often been heard. Furniture is moved around and the vacuum cleaner has sometimes been unplugged during morning cleaning sessions.

This small boy often appears when other children are present, and in recent years the building has been used as a centre for young people. On one occasion he was seen in the former drapers shop at the rear of the building by another boy who immediately contacted the duty staff and described the ghost. This description was exactly as the staff had witnessed, including knickerbockers and a waistcoat with a grey and blue transparency.

The most disturbing of sightings was made by a member of staff who saw the ghost on the stairs, crying and sobbing hysterically. The museum assistant came in early one morning and could hear a child crying. She went outside to see if someone was lost but, finding nothing, returned inside. Looking over at the stairs, the figure of a boy of approximately twelve years of age in Georgian costume appeared, kneeling down and crying.

The walls of the Great Hall of Leicester Castle have witnessed many turbulent scenes in its 900-year history, and the cells, used more regularly in the last two centuries after the building had been converted to its most recent function as the County Court, seem to be the focus of paranormal attention.

The sounds of cell doors banging shut, arguments between unseen prisoners and loud sobbing noises have all been heard upstairs in the main building. People working in the hall would often see and hear the bells from the cell ringing, even though the cells were empty.

Leicester's most famous paranormal entity, Black Annis or Anna, also has an association with the castle. Anna was said to live in the cellars, at least at some time and according to some accounts. She was also active not far away, on the cobbled path towards the Newarke, where she pounced on individuals passing beneath the Turret Gateway.

Further away from the centre of Leicester, a Victorian woman has frequently been heard in the upstairs rooms of Belgrave Hall. Sometimes, fleeting glimpses of her have been witnessed by staff. Occasionally, the aroma of cooking has been smelt inside the Hall when nothing has been cooking. The smells are mainly of fresh bread, stewed fruit and gingerbread, all generally regarded as 'old-fashioned' cooking constituents.

In 1998, several members of staff were discussing work near to the main door of Belgrave Hall when one of the group turned very pale. He said that while they were talking, in the corner of his eye he saw a woman in a 'terracotta-coloured Victorian-style dress' walking down the stairs and turning into one of the adjacent rooms. When he looked at her, she disappeared. Another member of staff saw the same figure on the first-floor landing. Footsteps are often heard on this landing, doors close of their own accord and room alarms are mysteriously activated when no-one is present.

However, Leicester's oldest buildings do not have the exclusive rights to paranormal activity. There are other rather unusual locations, some apparently totally lacking in 'atmosphere', including a concrete city-centre office block, the changing rooms beneath the tarmac surface of a school playground, and a council house on the Netherhall Estate.

The Netherhall Estate is not particularly known for psychic activity, except for one instance in 1991. A family – who not wish their address to be recorded – reported the appearance of mysterious drops or puddles of liquid, which would form and then just as quickly disappear. The liquid was said to be 'silky' to the touch. A lady with dark hair was seen, it has been reported, when an exorcist came to investigate.

This event has some similarities to the experiences of another family in the Highfields area in 1933. On this occasion, something flooded rooms and dripped water profusely from ceilings and walls. The family eventually escaped by moving into the house adjoining, but the scourge of the water followed them.

It would seem that there is hardly a postcode area of Leicester which does not lay claim to at least one unexplained presence. The building next to the Cathedral on the corner of Guildhall Lane and the narrow cobbled path by the side of the east end of the Cathedral, known as St Martin's East, is said to be haunted. There are certainly plenty of spirits there, as the building is now a champagne bar. Of particular interest

to those who seek the unexplained is the spiral staircase by which customers descend to the cellar area below street level.

These cellars and their connections beneath the heart of medieval Leicester constitute a story that has yet to be investigated in detail. Although most stories of tunnels connecting the clock tower with the Guildhall and other popular local landmarks can be discounted, there is incontrovertible evidence that many of the cellars beneath the older part of the town did connect with each other at some time.

A former warehouse manager at Wathes, the retail store which operated from buildings facing St Nicholas Place, formerly Highcross Street, is adamant that he used the cellars to store incoming goods and that these underground areas extended beyond the perimeter walls of the building. An undercroft beneath a yard at the rear of the building, close to Guildhall Lane, has been known about since Victorian times and was the subject of a major archaeological dig prior to the construction of the present BBC studios on the site in 2004. Roman and Norman remains were amongst a wide range of finds recorded during the investigation.

Another former employee of Wathes, who also once worked for a legal firm in New Street, remembers being taken down to the cellars in New Street and being shown a heavy, locked door. She was told this led into further cellars and tunnels, one of which connected with the cathedral. There is a further deep cellar, below the present cellar, in Greyfriars, which is also now sealed.

No doubt the explanation for these subterranean passageways lies in the extensive building development in the area during Victorian times, and may include the lower levels of the St Martin's Centre, the former Wyggeston Boys School. But why they appear to have been connected, and for what purpose, remains a question for further investigation.

On the opposite side of the river at the Donisthorpe Mills on Bath Lane, which has now been demolished, the yard was said to be haunted. The presence was known as 'Ivy', who was described as a short woman who always wore dark clothing, had grey hair, and whose face was covered in warts. One nightshift worker who ventured out for a quick cigarette is said to have encountered her. He never went outside alone again.

A ghostly prostitute by the name of 'Polly the High Kicker' is said to frequent Short Street, just off the central ring road, near St Margaret's Bus Station and the Mansfield Street police station. Polly apparently worked that area and was murdered by a sailor.

Further away from the city centre streets, Groby Pool, Braunstone Hall and, of course, Bradgate Park (with Leicester's most famous ghost, Lady Jane Grey) all claim regular hauntings. The Grange Farm Pub in Oadby was once a farmhouse. Apparently, most of the family who ran the farm died in the building, and still wander around the premises presenting, understandably, a morbid countenance.

In the 1980s, in Aylestone Park, a phantom woman dressed in black with a white face was encountered by a park ranger while he was on night patrol.

The Bridle Lane Tavern on Willow Street, on the St Matthew's Estate, is said to be haunted. In the same area, a group of burning or burned children has been seen by a local resident, walking towards him.

The roll call continues. Gilroes Cemetery has a 'veiled lady' who was seen in 2008 wearing Edwardian or Victorian mourning dress. Two witnesses saw her and described her as a shadowy veiled woman. The figure disappeared into a hearse, and when the witnesses checked the vehicle, it was empty

An Edwardian child was seen in the Haymarket Theatre, in the 1970s, soon after the theatre was built as part of the Haymarket Shopping Centre. In fact, he has been seen of many occasions, normally during rehearsals, always dressed in a sailor's suit. Before the theatre was built, a child once drowned in a well on the land. A little further away, Leicester's Little Theatre in Dover Street is reputedly haunted by a former manageress dressed in Second World War clothing.

To add some twenty-first-century candidates to this roll call of the inexplicable, there are three further pubs and several night clubs – the Long Stop, the Cricketers and the former Freewheeler, where strange events have been reported. An exorcist was called to the Freewheeler in 1972 because staff reported seeing a strange ghost that would change shape.

We must also add the Britella factory in New Pingle Street where, in the 1970s, workers threatened to go on strike unless the management attempted to exorcise the ghost, known as 'Friendly Fred', which had taken up residence there. The paranormal happenings were the subject of a report broadcast by ATV Television in January 1973. Those who investigate such matters say that the factory, which was located near the Frog Island industrial area of the city, is on a ley line which starts in Oadby and ends in Bradgate Park.

There are several very colourful stories that are the material of legend and folklore. One of the most appealing refers to the origins of the name Belgrave. It is said that the village was named after a giant by the name of Bel who died in the area. He tried to jump between Mountsorrel and Leicester in three dramatic leaps, but apparently failed and thus fell to his death. Back in the mists of time, in April 1389 according to some documents, a dragon spitting fire was seen flying over the town. Six months earlier, balls of flame were seen spinning through the sky. The combined events suggest some form of cosmic event although of course, it might just have been a close encounter of the third kind.

So Leicester can boast a wide and diverse collection of paranormal sightings, which appropriately span the full two thousand years of the city's history. Not only do these phenomena occur in our oldest buildings, but also in very modern structures built just a few years ago. They also appear underground, high up in roof spaces and in the open air, but mostly during the hours of darkness or when a building is empty or unoccupied.

Together, these accounts offer a fascinating roll call for the paranormal researcher and the local historian who can both find rich material for further research together. The real challenge is in separating the historical and physical facts from the rumour and speculation, whilst respecting at all times the reality of peoples' fears and emotions.

CHAPTER TWO

Myth and Superstition

The unexplained and the inexplicable frighten us today, and have always frightened human beings. The origins of belief, superstition and folklore lie back in pre-history, in that time before history was written down, and when the entire history of the race was handed down from generation to generation in an oral tradition.

Possibly the very earliest legend relating to Leicester is, appropriately, about its origins. The medieval chronicler Geoffrey of Monmouth, writing in the twelfth century, repeated the even earlier tradition that Leicester was founded by a mythical pre-Roman leader called King Lear. Shakespeare probably drew upon Monmouth's work – or a rewriting of it by Raphael Holinshed – as a basis for his celebrated tragedy.

The story has its origins in the fact that the river which flows through Leicester, the River Soar of modern times, was previously known as the Leir, a name which probably derives from *Ler* or *Llyr,* which are both Celtic names for a water god, similar to the gods Poseidon or Neptune in Greek and Latin myths. The Celtic name for a settlement by the side of the Leir would have probably been Caer-Leir, which was later translated literally by the Saxons (as in the tenth century) as *Legra-ceastar* and in the Domesday Book as *Ledecestre.*

Among the deities of Celtic mythology was a figure by the names of Ana, Danu, Anu or Don. This goddess corresponded to Demeter in Greek mythology and Ceres in that of the Romans. She was regarded as the mother of all the gods, presiding over the earth and the crops that grew on it. In order to propitiate her, to ensure successful crops and good harvests, almost certainly human sacrifices were made. Perhaps the powerful story of Black Annis is some faint echo of these much earlier beliefs in supernatural entities.

Is it a coincidence that the cave that was home to Black Annis was in the Dane Hills, outside the west gate of the town? Some have proposed that this area was originally called the *Hills of Dann, Dann* being one of the alternative names for *Ana* the goddess.

Looking further into traditional practices linked to belief and folklore, the hare has been associated with witchcraft and supernatural practices for many centuries, and until fairly recently, an Easter Monday Fair was held each year on the Dane Hills. This

bears a close resemblance to the world-famous bottle-kicking contest between young men from the neighbouring Leicestershire villages of Hallaton and Medbourne. This contest also takes place on Easter Monday, and involves the cooking of a Hare Pie, in this instance by the oldest female resident of the village of Hallaton, which is then cut into pieces and thrown to the spectators.

Also associated with the Black Annis legends are two very old and primitive places of belief and worship to the east of the old town. These are the sacred stones of the Holy Stone, Hellstone or Humber Stone, still to be seen and visited on the ring road in the Humberstone area, and the St John's Stone, which was located in fields once owned by Leicester Abbey that have become part of the Stadium housing estate, built partly on land reclaimed from the old Blackbird Road greyhound and speedway stadium. Its approximate location today, if portions of it have survived, is in the area of Somerset Avenue and Milverton Avenue.

These two standing stones may well be the two most important remains of prehistoric religion and belief to be found in this area. Until the middle of the nineteenth century, both these stones stood well above the ground. The Humber Stone now lies below ground level, but is clearly visible because the surrounding soil has been excavated.

The St John's Stone, or Little John's Stone, now seems to be lost. It was described as a pillar of sandstone embedded in sand and it stood upright in a field owned by Leicester Abbey, later called Johnstone Close. The earliest known document referring to the stone dates to 1381 and is a Cotton manuscript in the British Library.

At the beginning of the nineteenth century, it was reported to be standing about seven feet high, but by 1835, because of the wear caused by people scraping items against it, it had become reduced to about three feet. The celebrated Leicester artist John Flower made a drawing of it in 1815.

The St John's Stone was visited on 24 June every year, the day that was sacred to the memory of St John, when a festival took place that recreated the ancient festivals of old fire and sun worship. It was believed that both stones, but in particular the St John Stone, were the haunt of fairies, and that it was therefore wise to leave the area well before darkness fell. It is believed that fairies always congregate on ground that at some time has been sacred.

A custom existed, from time immemorial until the last century of paying an annual visit to the St John's Stone on St John's Day when 'a festival was formerly held there, a vestige of old fire or sun-worship.' Children who played there were careful to leave before dark, for then, it was said the fairies came to dance there. This superstition attests the religious significance of the monolith, for fairies, all the world over, continue in popular imagination to haunt ground that has once been sacred. A 'terrifying and deep groan' has been documented as emanating from the direction of both of the stones.

It is said that a tunnel ran from the Humber Stone to Leicester Abbey, a distance of several miles. There are further stories of dubious 'goings-on' relating to a nunnery at one end of the tunnel and an all-male abbey at the other. And to confuse the narrative, Black Annis yet again appears, sometimes occupying this subterranean entrance to

Leicester. The Leicestershire antiquarian historian John Nichols, in his celebrated *History and Antiquities of the County of Leicester* (1795-1815) says:

'Near the same place is a stone, which confirms the generally-received opinion of naturalists concerning the growth of these bodies; for, notwithstanding great pains have been taken by a late proprietor of the land to keep it below the surface, it defeats his efforts, and rises gradually...'

Other antiquarian histories have reported that ill-fate has befallen those who have tried to tamper with the stone. *The Gentleman's Magazine* (1813) printed the following note:

'Some old persons in the neighbourhood, still living, remember when it stood a very considerable height, perhaps 8 or 10 feet, in an artificial fosse or hollow. About fifty or sixty years ago the upper parts of the stone were broken off, and the fosse levelled, that a plough might pass over it; but, according to the then frequent remark of the villagers, the owner of the land who did this deed never prospered afterwards. He certainly was reduced to absolute poverty, and died about 6 years ago in the parish workhouse.'

As well as holy stones, there are a number of holy wells in the Leicester area, all of which were said to have medicinal and supernatural qualities. The well at Sketchley, near Hinckley, was said to improve one's intelligence, a unique claim as most attended to a person's physical ailments.

As recently as the early years of the twentieth century, some ceremonies and traditions in Leicester and Leicestershire respected customs and beliefs that almost certainly had their roots in Pagan times. Many of these were seen as an excuse to misbehave, or to be 'occasions of licence or misrule' to quote Lt-Col. R. E. Martin, who wrote about these matters when he was Chairman of Leicestershire County Council just before the outbreak of the Second World War.

Many of these activities took place around Easter time, usually on or near Shrove Tuesday. In Hinckley, on that day, anyone could go into the parish church and ring the bells, providing they paid a small fee. At Frisby-on-the-Wreake, the schoolchildren would ban their teacher from entering the school buildings until he had promised them an extra holiday. The rhyme that the children would chant has survived into the twenty-first century:

Pardon, Master, pardon,
Pardon in a pin,
If you don't give a holiday,
We won't let you in.

Back in the heart of the old town of Leicester, a strange tradition was enacted every Shrove Tuesday in the Newarke.

This was known as the Whipping Toms. The day began at 9.00 a.m. with a fearsome game, possibly similar to modern-day hockey, played between two teams (or crowds) of men armed with sticks with which to hit a wooden ball. The two ends of the Newarke – a considerable distance – were the 'goals'.

In the early afternoon, the Whipping Toms appeared, dressed in blue smocked frocks and carrying long wagon whips. With them were three men carrying small bells. Together they walked the area, driving out the men and boys who had been playing hockey. This would often degenerate into a very rough brawl which led the corporation in 1846 to bring the tradition to an end.

The roughness of this and similar traditional events such as the Beating of the Bounds, with an emphasis on beating and whipping, all have their roots in pagan belief. The threat of physical punishment or pain is probably some survival of the ceremonial of sacrifice.

In Leicester and its surrounding county, there has always been a considerable body of folklore associated with the practice of divination. The following story was told to Lt-Col. Martin in the years between the two World Wars and is recounted in his words:

'The hero of the story was an old forester, who was born and lived in a little house on Charnwood Forest, which is still standing though considerably altered during recent years; he may have been known to some of my readers; it was the late Mr. John Whitcroft of Ulverscroft. He lived to a great age, and was the last survivor of those who remembered the Forest before the Enclosure in the 20s and 30s of last century.

I will tell the story in the words employed in the introduction to Mr (George) Farnham's Charnwood Forest and its History. It happened upon that day that John Whitcroft's father found that two of his heifers were missing. He searched for them without success, and on the following Sunday he said to his son:

'John, you'd better take the pony and go round the forest, and see if you can make out anything of them heifers".

So John took the pony and rode from Copt Oak to Woodhouse Eaves and Swithland, enquiring without avail for the missing beasts. From Swithland he went on to Rothley, and as he rode down the hill to the gates of the Temple he met a man in a top hat who said to him : "You're John Whitcroft of Ulverscroft, and you're looking for two heifers". "That's true", replied John, "though it beats me how you know it. May be you can tell me where I shall find them". "No", said the man, "I can't do that; but you'd better go on into Belgrave, and into such and such a court. At the top of the court you'll find a house with a ring beside the door; hitch your pony up to the ring and knock at the door; my brother lives there, and he maybe able to help you ".

"Any port in a storm", thought John, and he rode on into Belgrave; he found the court and the house, and when he knocked, a man came out. "You're John Whitcroft", he said, "and you're here to ask me about some heifers; tie up your pony and come inside".

When they got inside the house, the man took something out of a drawer, turned his back and looked at it, He turned to Iohn and said: "Go back out of Leicester by

the Ashby road; when you get to Groby, look in the field on the right, as you come to the first houses, and you'll see a mob of cattle. Your heifers are there with them".

"I'm very much obliged, I'm sure", said John; "is there anything to pay?" The man would take nothing, and bade him good day.

He rode out by the Ashby road, and sure enough, when he came to Groby, there was the mob of cattle, and his father's two heifers among them.'

Finally, in this brief discussion of the roots of superstition and folklore, a note of some traditions that appear to be very local to Leicester and its county.

In times past, it was regarded as essential that bees should always be told when a death occurred in the family. If this duty was neglected it was considered that the bees would regard themselves as slighted, and would leave the hive. A piece of paper was sometimes put on the hive until after the period of mourning.

A local prescription for the cure of warts involved rubbing the wart three times with the rind of stolen bacon. The rind must then be nailed up on an outside wall, and as it dried up, the wart would also dry up and disappear. Another slightly grotesque treatment involved finding a black snail, rubbing it on the wart and then impaling it on a thorn until it died.

Warts could also be treated locally by rubbing the pod of a broad bean plant on it and then throwing the pod over one's shoulder without looking back, and by rubbing the wart with an apple cut in two, after which the apple is buried in a secret place. As the apple rotted, the wart would decay.

And a final cure-all, if all other remedies failed, was to seat the patient on a donkey with his face towards its tail and to give him a roasted mouse to eat.

CHAPTER THREE

The Belgrave Triangle

Three miles east of the centre of Leicester, and near to where the old routes from Leicester to Lincoln and Nottingham diverge, lies the small and ancient village of Belgrave. Since the suburban expansion of the nineteenth century it has been totally absorbed by the city, but the old centre of the village, along the Thurcaston Road, still retains some echoes of its earlier character. Leicester boasts no less than six ancient villages, which have been absorbed into the modern city, and all retain their church, manor and tavern. In Belgrave, these are the most prominent buildings that remain in the old settlement, structures that represent the life of almost all village communities. They are also the three buildings that have attracted the attention of paranormal researchers.

Unexplained events at these three locations, namely Belgrave Hall, the Talbot public house and the churchyard of St Peter's parish church, have prompted one local researcher of the paranormal to call the area the 'Belgrave Triangle', so giving the old village a new identity and the stories about its past a new viability.

An attractive legend suggests that Belgrave is, literally, the grave of Bel, the giant who boasted that he could reach Leicester from Mountsorrel (a distance of about five miles) in three large leaps. He mounted his sorrel mare at Mountsorrel and took one great leap to Wanlip. The next leap burst the horse's heart and harness at Birstall and the last leap, which was too much for both horse and rider, killed them.

Tradition says that Bel was coming for Annis – Black Annis – as his summer queen. His death may have locked her into the winter form in which she haunted and ravaged Leicester for centuries. The word *Bel* also has associations with Semitic and Celtic deities and with dragons as in one version of the Book of Daniel in the Old Testament.

But in the Domesday Book, the settlement is listed as *Merdegrave*. The original name derives from Old English *mearð* 'marten' + *graf* 'grove', but after the Norman Conquest, the first element was taken to be Old French *merde* 'dung', 'filth', and was therefore changed to Old French *beu*, *bel* – 'fair' or 'lovely' – to remove the unpleasant association. This change in name is confirmed by a twelfth-century writer who refers to the settlement as 'Merthegrave, nunc (now) Belegrava'.

For many centuries, Belgrave was a rural farming community adjacent to forest lands owned by Leicester Abbey, which had been obtained from Simon de Montfort. It was in the early years of the eighteenth century that the village gradually began to see changes that were to alter its position as a purely agricultural village. The building of Belgrave Hall in 1709–13 marked the beginning of the village's life as a residential suburb for the wealthier of the Leicester trades people.

In 1726, the road from Market Harborough to Loughborough, which ran through the village, was turnpiked. This led to more prosperity for the village inns including The Talbot Inn, and then the construction of the Leicester Navigation in 1791 connected the village to the industries of Leicester, and encouraged a host of cottage-based manufacturing enterprises to grow up.

The Church and Churchyard

The Church of St Peter's, Belgrave, dates back to the years following the Norman Conquest. Its tithes and property were granted to the Norman abbey of St Evroul (Orne) by Hugh de Grentemesnil some time before 1081. It was one of the wealthier livings in Leicestershire in the Middle Ages.

The main part of the present church was built in the thirteenth century, although some features of the twelfth-century church have survived, including the south

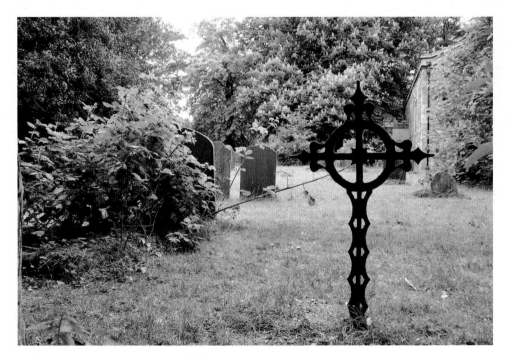

5 The churchyard of St Peter's, Belgrave.

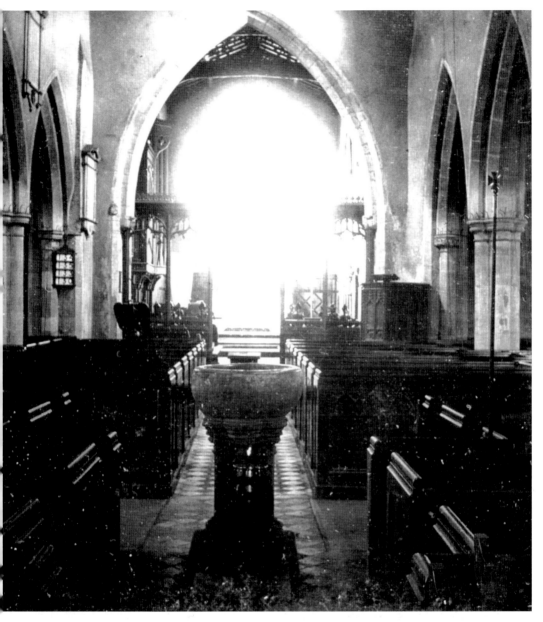

6 The Nave and Chancel of St Peter's Belgrave in about 1920.

doorway and the two lower stages of the tower. The nave and aisles and the present tower arch and lancet date from the thirteenth century. The chancel was entirely rebuilt in the fourteenth century, when the thirteenth-century piscina and sedilia were probably moved to their present position in the south aisle to make way for the more elaborate fourteenth-century ones at present in the chancel. The clerestory and the upper stage of the tower date from the sixteenth century.

In 1826, the south porch, which hides the old twelfth-century doorway, was built by William Bradley in a style different from that of the rest of the building. In 1832 and 1837, the chancel, which should have been maintained by the lessee of the tithes, was in need of repair. At this time the church had a lead roof throughout and the tower had a low leaden spire. New pews were fitted in 1857 and the church was extensively repaired in 1862. The choir vestry was built in 1877, when the organ and organ chamber were installed, and enlarged in 1908 when the clergy vestry was built. The north porch was added in 1912 and the church was re-seated in 1938.

St Peter's is now closed. Services take place at St Alban's in Weymouth Street, which is part of the same parish.

Sightings of a female apparition have been associated with this particular site. One witness reported having watched the figure of a woman clearly passing through one of the gravestones in the cemetery, before turning round and – somewhat cheekily – giving him a wave!

The Talbot Inn

Many old hunting inns can claim a resident ghost. This old hostelry's associations with the paranormal probably stem from its proximity to Red Hill where the local gallows once stood. According to local tradition, the Talbot was often the last place where condemned prisoners stopped on their way to their execution, where perhaps they were allowed one last drink. It is said that part of the building, which is now used as a garage, once served as a mortuary, but whether this was where the bodies of the executed were brought back from Red Hill is not confirmed.

The origins of The Talbot are unknown. Part of the underlying structure of the present building possibly dates to the eleventh or twelfth centuries, but the form and purpose of this early building is not known. Clearly, to be a substantial stone structure of that age would suggest a building of considerable significance within the local landscape.

The Talbot of later centuries was originally an inn that took paying guests. It was in an ideal position for such passing trade, located on the main route on the toll road into Leicester from Loughborough and the north before the opening of the Loughborough Road route. One can imagine both familiar faces and strangers meeting in the bar, the travellers exchanging news, which travelled up and down the coaching routes.

The oldest parts of the present structure are the cellars. One cellar is still in use. The other is bricked up. In the late 1950s, the inn was badly damaged by fire. In 1958, grants were obtained from the local authority to rebuild, and during the refurbishment

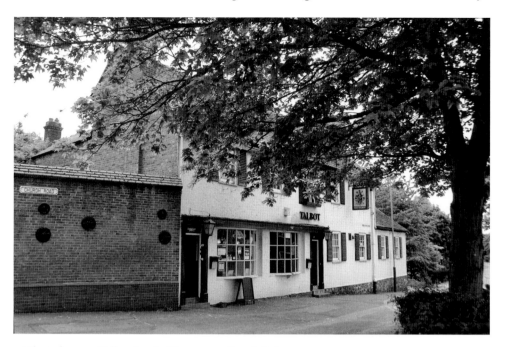

7 The infamous Talbot Inn in Thurcaston Road, Belgrave.

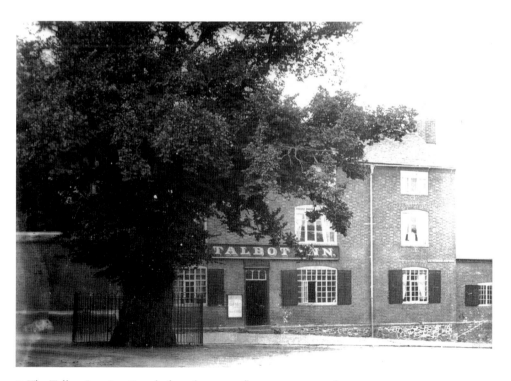

8 The Talbot Inn, in 1873, before the upper floor was removed.

the structure was reduced from three stories to its present two-storey form. From this point, The Talbot ceased to take in paying guests.

The fabric of the inn today dates for the most part from the eighteenth and nineteenth centuries, but behind the fixtures and fittings can be seen bricked-up arches, which some believe are priest holes, or possibly tunnels leading to either the hall or the church, thus connecting the three buildings in the so-called Belgrave Triangle.

Given the age of the building and its heritage, it is not surprising that many paranormal experiences have been claimed within its ancient walls. The ghost of a man with a disfigured face has been seen, and it has been assumed that he was one of those who had been hanged nearby. One landlady reported seeing a figure of a young boy in various rooms of the building, including the cellar. According to a succession of owners and tenants, equipment in the cellar has often been tampered with and stock has vanished with no easy explanation. Recently, paranormal investigators, staying in the pub overnight in separate rooms, heard the sound of movement and footsteps in each others' areas.

Numerous spirits have been sighted at the Talbot. The figure of a lady has been seen walking through a false wall late at night. She has long, flowing hair and was seen so often that the locals gave her a familiar name – Hairy Mary. It is conjectured that she is the ghost of a former landlady, Mary Dawson. Certainly, at the time that the Dawsons and their six children resided at the Talbot, the living accommodation for the innkeeper was in the larger of the cellars. Today, some staff will not enter that area.

Another previous landlady reported a further paranormal presence. The woman saw a shimmering figure on the verge outside the building, near to the car park. It was the height of a small man and it moved slightly. The landlady had been gardening and had paused to rest, feeling very warm. But what she saw made her shiver, and she later said she was frozen to the spot, unable to move through fear.

Other unaccountable appearances have included the figure of a small boy, which has been seen in the fireplace of the lounge. He was sitting on a stool, swinging his legs and smiling. This boy has also been seen in the cellar by the same person, a previous tenant of the inn. A man has been seen on a number of occasions, again by previous landlords. This individual appears next to the bar, wearing an old raincoat with a cape and carrying a leather purse. He has been seen to open the purse, look for some money and then turn to walk through the adjacent wall precisely at the point where the original entrance to the inn was located before refurbishment. A man's face has also been seen peering through a window at the back of the lounge. It is said that he is much disfigured.

A team from the *Haunted Britain* website paid a visit to the Talbot a few years ago, and I am indebted to them for the following remarkable reportage, which they have published online, together with many fascinating images and video footage.

The team started its investigations soon after midnight in two locations, the main bar and the basement. Within moments, the two members of the team in the basement encountered a woman staring down at them looking very upset at the unwarranted late-night intrusion. They later checked a fixed camera that had been set up in the bar area and noted a 'light anomaly' which had been recorded whilst the investigators in that area had been downstairs with their colleagues in the basement. Soon afterwards,

the light reappeared in front of them, some three feet from the camera, moving towards the bar.

During the remaining period of the overnight investigation, one of the team received an inexplicable scratch across his lower back. In the basement, a further light anomaly was seen circling another investigator, and another was caught on camera in the bar. When reviewing the photographic footage, *Haunted Britain* reported 'compelling evidence' of a paranormal presence in the form of a man's face looking down upon one of the team in the main bar.

The Hall

Belgrave Hall was built by Edmund Cradock, a self-made hosiery merchant, between 1709 and 1913. He died soon after its completion. Little is known of the next owners, the Simons. Later, the Vann family lived at the hall, from 1767 to 1844, and ran a thriving hosiery business from the hall's outbuildings, employing many local framework knitters as outworkers. The Vanns gave generously to a number of local charities including Leicester's first free school.

John Ellis, who purchased Belgrave Hall in 1845, was also noted for his good work in the community. Ellis, another wealthy businessman, was responsible for bringing

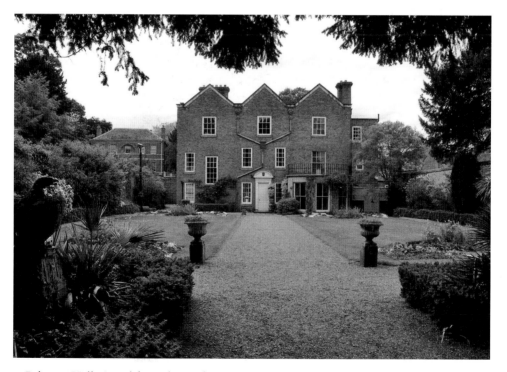

9 Belgrave Hall viewed from the gardens.

10 Closed-circuit television equipment overlooking the gardens at Belgrave Hall.

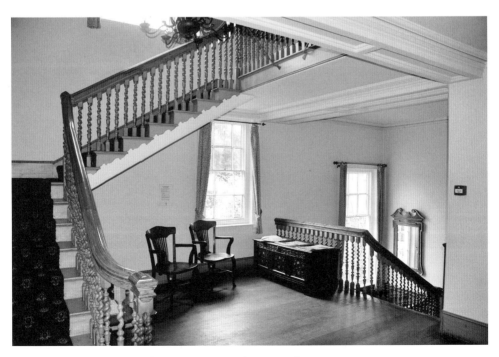

11 The staircases and first-floor landing in Belgrave Hall.

the railways to Leicester in 1833. The hall was sold to Leicester Corporation in 1936, who converted it into a museum.

The Hall has had a longstanding reputation for being haunted, but it was not until relatively recently that the wider public became aware of its paranormal history. Previously, the figure of a woman in a long terracotta-coloured dress and black boots had been seen by staff at the Hall. The lady, according to former gardener at the hall, Michael Snuggs, walked down the stairs and paused to look through the window at the garden one day. He claims she then turned, smiled and walked through to the kitchen and disappeared. Some believe this figure is Charlotte Ellis, a daughter of John Ellis.

Another frequent sighting is referred to as the 'Victorian Lady'. She has often been heard by staff members walking around the upper floor. There is also a 'Green Lady' and a 'Grey Lady' who both appear on a regular basis throughout the grounds and building.

Inexplicable footsteps, which seem to originate in empty rooms and on deserted staircases, have been reported with increasing regularity. Several of the staff working in the house claim to have sensed the smell of cooking coming from the long disused kitchen. One detected the scent of a casserole being prepared and others say they have clearly recognised the smell of bread and gingerbread baking. The only kitchens in the building today are static museum exhibits.

The stories and rumours of hauntings at Belgrave Hall became national news in December 1998 when the *Leicester Mercury* printed an image from the video recordings of the hall's closed-circuit television cameras covering the outside of the building.

The photograph had been made available to the newspaper by the person responsible for marketing Leicester's museums. The fleeting image – which in real time lasts no more than a few seconds – allegedly showed two luminous figures, one wearing a long flowing dress complete with a bustle, surrounded by a halo of light. A ball of mist or fog was also seen swirling over the garden in the background at the same time.

The curator at the time, Stuart Warburton, noted that the security cameras at the back of the hall had been triggered at about 4.50 a.m. 'The camera freezes for about five seconds and then the figures disappear. And then we have a mist that swirls along the top of the wall, which we cannot explain'.

The video footage was given further prominence by BBC Radio Leicester in their news bulletins on the same day, and by the evening both main television news channels of that time – BBC and ITN – screened the recordings in their main bulletins. The free national publicity worked its own magic on the number of visitors to Belgrave Hall and Gardens, which increased ten-fold in the weeks that followed.

The ISPR – International Society for Paranormal Research – was granted the opportunity to study the reported phenomena. The team's observations confirmed that there was not one but a number of ghosts inhabiting the hall, but they were unable to find any evidence of any paranormal activity in the area behind the hall where the figure had been recorded on video.

Inside the building, members of the ISPR team said they encountered a 'strong, negative energy' located on the upstairs floor. The male energy was so negative it,

it seems, that it forced them to leave it in peace as they were afraid it would hurt someone or cause damage.

They also encountered a small child-ghost that had died of Tuberculosis, as well as a well-known cook and a man who had fallen and hurt himself (possibly fatally) on the stairs. Almost all of the entities they encountered were confirmed to have existed with accounts and history of the Hall. The ISPR Team say they had no prior knowledge of the history or the families who had lived in the hall.

The ISPR concluded that Belgrave Hall was indeed very haunted. They took evidence of many 'Cold Spots' where the temperature would suddenly and dramatically drop. They felt many residual forces and energies that affected their psychics in various ways.

They concluded that the ghostly inhabitants were friendly and were mostly part of one of the original families who owned the Hall. The only negative energy was the upstairs negative male, who is thought to be possibly dangerous and best left alone.

After examining the security video footage that was thought to possibly contain a ghost, ISPR concluded that the footage and the strange image were 'environmental' meaning that they had not been caused by a paranormal force. Various attempts were made to create the image by placing various materials on the camera's lens. The closest match was a leaf.

The ISPR state that if the recorded shape was indeed a ghost, then the depth of field and the size of the lens would have meant that the figure would be over ten feet in height. They also noted that the image appeared for the same amount of time as a raindrop appeared. Apparently, ghosts do not normally appear and disappear so quickly on film. They tend to linger and move about.

They also decided that the mysterious-looking fog that appeared suddenly in the background of the video image was simply fog. The weather that night was light rain with low temperatures, the climatic conditions right for English fog to appear at dawn.

The BBC also set up an investigation of the three sites, which was recorded on Saturday 13 October 2000. The BBC brought together members of the West Midlands Ghost Club, the Black Country Paranormal Society and ASSAP, the Association for the Scientific Study of Anomalous Phenomena.

On the night, the researchers were divided into three teams of four people. On the landing of the second floor of the hall, the relevant group reported the sound of 'something akin to a female sigh'. This was corroborated by two other groups who were located above and below this point. At about the same time, a member of the team located in the hallway on the ground floor claimed to have felt a dramatic change of atmosphere, almost like having a panic attack. Much later, towards the conclusion of the night's vigil, a scratching sound that lasted for about thirty seconds was heard behind the door of the Curators Office on an upstairs floor of the hall. It was generally agreed that this was probably indicated nothing more than the presence of a rodent.

In the early hours of the morning, the investigators moved to St Peter's Churchyard. Two members of the group reported that they had the strong feeling that they were

being watched through the darkness. Later, the landlady at the Talbot informed them that they had been standing very near to the graves of two previous Talbot landlords.

In the light of the dramatic events reported and recorded by the ISPR team, little of significance occurred at the Talbot that night. Two loud thuds were heard but little else.

Black Annis –
Evil Personified

The witch is an image that still has a resonance and potency today. Children enjoy dressing up as them on Halloween, and more than one Hollywood blockbuster has presented the witch as a woman of glamour with certain attractive qualities. Yet we still use the term 'old witch' to describe a woman of senior years whom we may not like and, in my own childhood, the children of the neighbourhood stayed well away from a certain run-down dwelling near where we played because, it was said, a witch inhabited it.

In medieval times, perhaps every village and settlement had its 'witch' who mixed potions and could be heard uttering strange chants; but then, the Latin ritual of the Catholic service in the local parish church, with its incense and prayers, was just as mysterious.

Witches were a part of life and of death, and the character of Black Annis has haunted the minds of Leicester people for centuries. She has appeared in many different guises and has been known by several different names, but always Black Annis has been the childhood vision of evil, a shadowy figure that inhabits the dark corners of the town, moving about beneath the ground in tunnels she has gouged out of the stone by herself using her claw-like talons.

There have been written references to the 'Lady of Dane Hills' since as early as the seventeenth century. William Burton refers to her in his Description of Leicestershire, first published in 1622, as does John Nichols in his History and Antiquities of the Town and County of Leicester (1795–1815) and the Leicestershire poet John Herrick (1742-97) provided a description of her attributes in verse:

Where down the plains the winding pathway falls,
From Glenfieldville to Leicester's ancient walls,
Nature, or art with imitative power
Far in the glen hath placed Black Annis' bower

Yea, though the false truth of former days
Foul not the path where falsehood artful lay
Black Annis held her solitary reign
The dread and wonder of the neighbouring plain

Tis said the soul of mortal man recoiled
To view Black Annis eye so fierce and wild
Vast talons foul with human flesh there grew
And features livid blue glared in her visage
Whilst her obscene waist,
warm skins of human victims close embraced.

Black Annis is usually pictured as a witch, perhaps not unlike Shakespeare's 'brown and filthy midnight hags'. She is, of course, grotesque. She is old and very ugly with claws of iron and a liking for human flesh – especially that of young children. And those claws can reach right inside houses through open doors and windows to snatch her prey.

In some stories she is said to be extremely tall with long, yellow or white fangs, and maybe she has only one eye. At night she lurks the streets and alleys of Leicester in search of unsuspecting children and lambs to eat and, as John Herrick's verse confirms, she wore their skins around her waist after having hung them out on a tree by the entrance of her bower to dry in the sun.

Unlike many of her kind, she seems to be immortal, unlike many 'witches' who were shown to be only too mortal. In July 1616, no less than eleven no doubt innocent women from the village of Husbands Bosworth, in Leicestershire, were executed by hanging on the same day at Leicester Jail. It was claimed that they had bewitched the young grandson of the Lord of the Manor. On the testimony of this one young boy, eleven women lost their lives.

According to local legend, Black Annis used her iron claws to dig into the side of a sandstone cliff to make her home, outside the western approaches to the town of Leicester. It became known as Black Annis's Bower. In front of this cave stood a large oak tree in which she would hide in order to leap out and grab lambs and young children who had wandered too far from home.

In Leicester it was claimed that Black Annis's horrific cries could be heard up to five miles away, and when she ground her teeth the sound was so loud that all the people had time to lock and bar their doors. The little family houses in the town were barred by herbs hung above the windows. Apparently, this was why Leicester cottages only had one small window.

The location of her bower is still known to some. The Dane Hills area is now the suburban sprawl of Newfoundpool, Western Park and New Parks. The Dane Mills housing estate was built shortly in the decade following the First World War and covers the area in a square of land bounded roughly by the A50 Groby Road, A47 Hinckley Road, New Parks Way and Tudor Road. The present owner of a house near Western Park has told local historians that the deeds to his property describe the eastern boundary of his estate to be part of 'Black Annis Bower Close.'

By the late nineteenth century, the cave had been filled in and the area levelled. A contemporary account gave its size as being about 4–5 feet wide, 7–8 feet long and 'having a ledge of rock, for a seat, running along each side'.

There was a curious ceremony in the Dane Hills area every Easter Monday, which was also referred to as Black Monday. On that day, the Mayor of Leicester,

accompanied by various town dignitaries, set off for a 'hare hunt' at noon. The actual prey was apparently a dead cat that had been soaked in aniseed – the Cat Annis. According to documents from 1767, this gruesome ceremony involved tying the dead animal to the tail of a horse for a drag hunt that began at the Bower and went through the streets of the old town to the Guildhall. In later years, this event, which was more of a procession than an actual hunt, was replaced by the Dane Hills Fair.

There have many stories of secret tunnels beneath the old town area of Leicester, particularly in the area of the castle, the Newarke and that intricate network of little streets around the Guildhall and St Martin's. One of these tunnels was said to connect Black Annis' home to the castle in Leicester, which would have meant a route deep below the ground, under the bed of the River Soar and the town's defences.

Black Annis is also known to haunt the gateway of the castle as well as the Turret Gateway along the path to the Newarke, creeping along in the dark in her secret underground tunnel from the Dane Hills, and sleeping in the castle cellars. Intriguingly, the local historian James Thompson, in his Account of Leicester Castle, first published in 1859, provides a tantalising allusion to tunnels in this same area. He writes: 'Beneath the building are chambers and passages, as yet unexplored, and their purposes therefore undiscovered. That there may be subterranean means of communication between the Mount, this gateway, and other localities in the Newarke, is a conjecture founded on tradition, and not to be entirely and superciliously rejected.'

Although by the mid-twentieth century she may have lost her cave to housing development, Black Annis still had the power to frighten people. Folklore historian Ruth Tongue recorded this story of an evacuee to Leicester in 1941, which is cited on many websites devoted to the paranormal:

Three children collecting fire-wood began to get frightened as dusk fell, knowing that Black Annis only appeared after dark, because it was said that 'daylight turned her to stone. Sure enough, they heard strange sounds and, looking through the hole in their witch-stone saw Black Annis. Dropping their bundles of faggots, they fled as fast as they could. Black Annis stumbled on the dropped sticks, and cut her legs so badly that blood poured from them onto the ground. Mumbling to herself, the witch caught up with them before their cottage door. Just as she was about to lay her hands on them, their father emerged with his axe, and hit her full in the face with it. She ran off shrieking 'Blood! Blood!' but just then the Christmas bells began to peal and she fell down dead.

The witch of the Dane Hills is known by many names, and no-one is quite sure of her origins. She can be Black Anna, Black Anny or Black Agnes, all of which may be attempts to familiarise the less-familiar 'annis' into a better-known English first name. She is also Cat Anna or Cat Annis, which are reminiscent of the aniseed-drenched cat of Black Monday in Dane Hills; and cats have always been associated with witchcraft.

Some historians have proposed that the origins of Black Annis may be in Celtic mythology as in 'Danu' or 'Anu'. Bob Trubshaw, who is the undoubted authority on Black Annis, discounts the convenient similarity between 'Danu' and Danehills,

pointing to the fact that the local landowners were members of the Dannet family, and suggesting that this is a more likely source for the geographical name.

Donald A. McKenzie, in his 1917 book Myths of Crete and Pre-Hellenic Europe, suggested the origin of the legend may have its roots in the 'mother-goddess' of ancient Europe, seen as a being that devoured children. It has also been proposed that the legend may stem from a tribal memory of sacrifice to an ancient goddess.

More recently, the theologian Ronald Hutton has disagreed with most of these ideas. Repeating in part a much earlier theory, Hutton in his book The Triumph of the Moon: A History of Modern Pagan Witchcraft, postulates that the Black Annis of the Leicestershire legend was based on a real person called Agnes Scott. She was a Dominican nun who lived as an Anchoress, that is, someone who withdrew from secular society to live a prayer-oriented ascetic and hermit-like existence, and who cared for a local leper colony. She lived a life of prayer in the cave in the Dane Hills, and was buried in the churchyard in the village of Swithland, some miles distant of the town of Leicester.

Hutton proposes that the memory of Agnes Scott was distorted into the image of Black Annis, either to frighten local children, or because of an anti-anchorite sentiment that arose after the Reformation. In Victorian times, the story of Agnes Scott, or Annis, would become confused with the similarly named goddess Anu.

No English monarch has produced such an outpouring of loyalty and emotion as Richard III. Conventions are held annually in Leicestershire and new books about his short reign are published with remarkable frequency. And it is Black Annis that apparently confronted the king on his way to the Battle of Bosworth on 22 August 1485. As he led his army out of Leicester on that fateful morning, his spurs struck a stone pillar on Leicester's Bow Bridge. The witch leapt out, declaring loudly that it would be his head that would strike the same obstacle on his return.

After being killed on Bosworth Field, Richard's naked body was thrown across the saddle of a horse and his head, hanging down as low as the stirrups, hit that very stone. An engraved tablet was built into the parapet of the bridge when it was rebuilt in the nineteenth century with the explanation that 'his head was dashed and broken as a wise-woman had foretold, who before Richard's going to battle being asked of his success said that where his spur struck his head would be broken'. Again, a verse has ensured that the story exists today:
'The boar that has silver hue
The king's return shall change to blue
The stone that tomorrow his foot shall spurn
Shall strike his head on his return'

On the night before the battle, Richard stayed at the Silver Boar Inn in Leicester's Highcross Street. By the time the defeated king was returned to the town, the landlord of the inn had renamed his hostelry as the Blue Boar Inn as he did not wish to be seen as one of Richard's supporters.

There is more than one Black Annis in the United Kingdom. She seems to have sisters in many other places, including the Scottish Gentle Annie or Gentle Annis. Many 'hags' across England are said to be 'blue faced' as is Black Annis, such as

Scotland's Cailleach Bheur. These witches were originally the winter goddesses, their faces blue with cold. They brought with them a time of cold, dissolution and death.

Some authorities view the legends that surround Black Annis as local versions of Brighid or Brigantia, who is the dark mother goddess who took the souls of human children into her care. She may be the 'crone goddess' who brings winter, the dark lady who holds the souls of the dead in her embrace. But as the seasons change she transforms into the bright maiden of spring and her underworld tomb becomes the womb of rebirth. The Dane Hills area of Leicestershire, possibly from Danu, just may have been the centre of her cult.

Assuming that Black Annis was indeed a winter hag, then she would also have had a summer form as a beautiful young woman. Extending the legend wider than the walls of the town of Leicester, her husband may have been Leicester's well-known giant, Bel, for whom, locally, the Bel fires were lit at Beltane, which is the Springtide festival marked on the first day of May.

Bel was the giant who boasted that he could reach Leicester in three large leaps. He mounted his sorrel mare at Mountsorrel, some miles north of Leicester, and took one giant leap to Wanlip. The next leap burst the horse's heart and harness at Birstall and the last leap, which was too much for both rider and his mount, killed them both. They are said to be buried at Belgrave, just north-east of the Dane Hills, which is a place well-known even today for paranormal events.

The Humber or Holsten stone, which can still be seen close to a modern roundabout on Leicester's ring road, is also associated with this general tradition. It is said that the original plans for the access roads to the Tesco superstore at Hamilton were revised in order to avoid disturbing the stone. It is known as the Hell or Holy stone because it was said that fairies lived in it, and local people – who still shop at Tesco – have claimed that they heard groaning sounds from its vicinity.

Tradition suggests that there was a nunnery near to the Humber Stone from which ran a tunnel to Leicester Abbey. The tunnel and the groaning bear a notable resemblance to the stories of Black Annis, especially as it has been further mooted that there was once a cave near the Humber Stone, called the Hell Hole, where Black Annis was occasionally said to live. This was known as the Hell Hole.

The speculation continues in suggesting that the name 'hell' may be from the same word root as 'holy' but it could also be derived from Hel, the Nordic goddess of the Underworld. Although Hel's name was taken by the Christians for their place of perpetual torture, the kingdom of the goddess was one of ice and cold, as perhaps portrayed by C. S. Lewis in his stories of Narnia. She is the progeny of Loki, the Trickster, on Angerboda. Hel was one of three children and it was Odin himself who gave her the underworld – or subterranean – kingdom of Nifleim, the 'mist world'. Hel is portrayed either with a face which is half human and half blank or she is shown as being half black and half white – and even, blue.

Strange events do still occur in the vicinity of Black Annis' lair. Each year on Midsummer's Eve, a group of local women dance on top of Black Annis' bower at a secret location in the Western Park area of the city. They also meet every Thursday evening to rehearse at the West End Neighbourhood Centre.

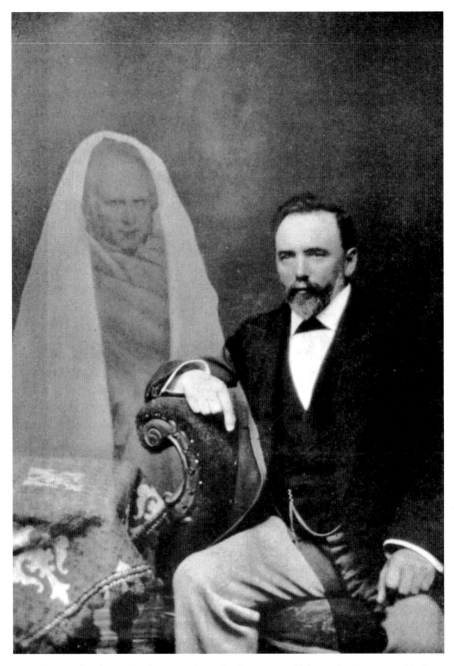

12 An image by the spirit photographer Charles Boursnell from about 1900, of Robert James Lees and an alleged spirit friend.

Robert James Lees – Man of the Mists

Paranormal activity is normally associated with a place, but in the case of the Leicestershire medium Robert James Lees, events that can only be described as paranormal followed him wherever he went, according to contemporary accounts by his friends and family.

Lees was born in Hinckley in 1849, just months after the famous Hydesville Rappings in New York State prompted the rebirth of Spiritualism, first in America, and within ten years in the United Kingdom.

He was born in a room between two public houses on Bond Street in the town, in a bedroom above a bakery. Both inns were owned by his maternal uncle, and Lees's father, William, was the landlord of one of them.

Later in his life, Lees recalled that as a small child, still in his cot, he 'saw' a friendly and aged Highlander who would keep him company at night until he fell asleep, but the first alleged psychic event that came to the notice of his family took place when the boy was about ten years old.

There are several accounts of this first encounter with the paranormal, and some sources conflict regarding certain details, but the basic story is that the Lees family, having fallen on hard times due to recession, moved to a house in the town that had a very low rent on account of a rumour that it was haunted. The young boy 'saw' another boy in the cellar of the house and told his father. The authorities were brought in to dig up the floor of the cellar, and the body of a young boy was discovered. Later investigations revealed that a previous occupant of the house had reported that their son had gone missing. The previous occupant and his wife were later charged with his murder.

At about the same time, the boy Lees would wake at night in a trance, and on one occasion 'became' the late Prince Albert. It is recounted by Lees's eldest daughter, Eva, that her father's nocturnal trances were discussed with his Sunday school teacher who visited and arranged a séance, at which Prince Albert 'came through'.

The industrial revolution had led to a dramatic expansion of scientific discovery, and to an era in which superstition and a fast-expanding understanding of physical scientific facts existed side by side. In Victorian England, alongside the developing scientific principles of research and exploration, accusations of witchcraft were still commonplace

13 Robert James Lees's final home in Leicester in Fosse Road South.

14 The Queens Head in Bond Street, Hinckley. Lees was born in the upper room of the small building on the right of the pub.

15 Robert James Lees, photographed in about 1875.

and taken very seriously. As we become more able to make sense of the physical and the tangible, the supernatural and intangible become even more mysterious.

Charles Darwin's theories on evolution were published in 1859. They prompted not only controversy and debate, but also a new age of philosophical thought. By the time the young Lees was beginning to explore his world, Darwin's radical approach to the age-old assumptions based on the faith of past generations, was influencing many areas of research. It was a time when a belief in the spirit world was accompanied by physical experiments in order to give the research a pseudo-scientific authenticity. Ultimately, this led to the setting up, in 1882, of the Society for Psychical Research whose investigators were inclined to talk about their experiences in the form of scientific prose, speaking, for instance, of 'magnetism' and 'vibrations'.

16 A classic portrait of Robert James Lees, taken in about 1920.

Oct. 5th,
New Moon.] **SEPT. & OCT, 1888.** *[Sun rises 6h. 0m.* 30th,

SUNDAY 30 [274—92] 18th after *Trinity* vote for self

Kensal Green debate – Ipm Conservative

Peckham — Ipm in Early to meet ch

MONDAY, Oct. 1 [275—91]

Cambridge Michaelmas Term begins

TUESDAY 2 [276- 90].

Offered services to Police to follow up
East End Murders — called a fool
and lunatic

Got Trace of man from the spot in Bower
Street

WEDNESDAY 3 [277· ·89]

Went to City Police again — called a
madman and fool.

17 The diary of Robert James Lees for September 1888, in which he refers to the Whitechapel Murders.

An article by one psychic investigator, A. J. Davis, in *The Herald of Progress*, published in 1862, is a typical example of the type of phenomena being investigated at that time, and the pseudo-scientific approach adopted by investigators. Davis precedes his report with a reference to previous research into the subject:

'We have positive knowledge of houses that have been 'haunted' and so absolutely that no family could be induced to live within their walls.'

In this particular article, which is one of many similar pieces, Davis recounts the story of a family in which an only son had committed suicide, two small children had burned to death, and their mother had consequently thrown herself to her death from an upstairs window 'in a fit of frenzy'.

It would seem that Lees's Sunday school teacher, like so many educated men of the time, had a fascination with Spiritualism, and so reported the events to the distinguished journalist Hannen Swaffer. Swaffer was also a spiritualist and campaigned vigorously to present Spiritualism as an accepted faith in England.

It is claimed that Swaffer published an account of the young Lees's activities and abilities in one of his spiritualist journals, which was sent to Queen Victoria, and in response, two members of the Queen's court arrived unannounced at the Lees home.

Unfortunately for the historian, not one item of evidence can be found to support this story. No record of the murder of a young boy in Hinckley at that time has been found. The article that apparently ignited Queen Victoria's interest in spiritualism and prompted her to call the young Lees to her court has never been found, even though complete runs of *The Medium* and *The Daybreak*, which Hannen Swaffer edited, exist in several archives.

Robert James Lees grew into manhood and married a girl from his Sunday school class, Sarah Ann Bishop. They moved to Manchester after the birth of their first child, Norman. Lees had been apprenticed to a printer in Birmingham, and this gave him the qualification and experience to secure a post with the *Manchester Guardian* in the north of England.

In 1874, after the birth of three more children – all boys – the couple moved to London. The move was prompted by an assignment given to Lees to spend some time in the capital providing information about London's varied newspapers and journals as part of the *Manchester Guardian*'s plans to set up a southern edition. Whilst in London on behalf of the *Guardian*, he was enticed into joining one of the myriad of new 'penny dreadfuls' as its advertising manager. The journal folded after a few issues and Lees was left unemployed, penniless and seriously in debt.

It is at this moment that another paranormal event in Lees' life is reported. Indeed, the report is in Lees's own words, in his autobiographical novel *The Heretic*. Just at the point where bailiffs arrive to remove his possessions and to evict his family from their tenement, Lees considers suicide by jumping into the River Thames from London Bridge. Then, a stranger appears who knows all about Lees' problems, and offers accommodation and who, by his regular visits and interventions, places the young family on the road to financial recovery.

In addition to the claims that Lees served Queen Victoria as a 'boy medium', and in return for his appearances at the court received a pension from the Privy Purse, another very well-known claim is that Lees knew the identity of the Whitechapel Murderer of 1888, Jack the Ripper.

The large number of references to his alleged involvement, in books, films, journals and newspapers, would lead one to believe that Lees spoke freely of these experiences. Yet the opposite is true. The only reference in Lees's own hand to even a passing interest in Jack the Ripper is in his own diary for the week of the double murders. Here, in just a few one-line statements, Lees reveals that he 'sensed' the perpetrator of the crimes at the murder scene in Berner Street in the Whitechapel district, offered his assistance to the police, both locally and at Scotland Yard, and was turned down, being called a fool and a madmen.

The only other 'evidence' of Lees's interest or involvement in the Whitechapel Murders' investigation was a letter purported to be in the hand of Jack the Ripper himself. Yet research has now proved that an incorrect reading of one vital word in the letter led the earlier 'ripperologist' and writer, the late Stephen Knight, to the wrong conclusions.

The letter, allegedly from Jack the Ripper and dated 25 July 1889, which Stephen Knight claimed referred to Robert James Lees, is a red herring. Researcher and author Stewart P. Evans has shown that the apparent reference to 'with all your 'lees' actually reads 'with all your 'tecs' as in 'detectives'.

The first known published article linking Lees with the Ripper murders was the now largely discredited *Chicago Sunday Times-Herald* feature of 1895, and it is this article that is the source for almost all the subsequent references to the medium's alleged involvement. Even when a number of English national newspapers reprinted the Chicago story soon after its publication, Lees did not make any public utterance, and there remained a profound silence regarding the events until shortly before his death in 1931.

It is important to emphasise that neither Lees nor any member of his family, nor any police officer involved in the Ripper investigation, nor any Spiritualist organisation, made any public statement linking Lees to the Whitechapel Murders. Various newspapers covered Lees's other activities, such as his fight on behalf of the Temperance Movement in St Ives, Cornwall, and the dramatic healing of a young girl in Ilfracombe, yet no journalist in any of the subsequent published material made any reference to Jack the Ripper. Not even Lees' own autobiographical account of his time in London, covering the period from 1878 to 1895, makes any reference, no matter how oblique, to the events.

Then, in 1928, shortly after Lees and his daughter Eva returned to his native Leicestershire, the *Leicester Illustrated Chronicle* published a feature in which Lees stated that he had been instrumental in the apprehension of Jack the Ripper. The article was written by Hugh Mogford, a convert to Spiritualism, who had encountered Lees some years earlier in Ilfracombe.

After Lees's death in 1931, two English national newspapers, *The People* and the *Daily Express* ran major articles that were straightforward rewrites of the old Chicago story. From family papers of the time that have survived, it is obvious that neither Eva,

nor Claude Lees, who were both living in Leicester at the time of their father's death, contributed to these articles. In fact, Claude wrote to the *Daily Express*, demanding to know the source of the story, a request that was politely but firmly refused. Eva, in an interview with *Le Matin*, insisted that she had no knowledge of the identity of Jack the Ripper, and did not wish to talk to any journalist about such a distasteful episode. When pressed, she would only state that it was true that her father 'played some part'.

It is also apparent that the major spiritualist organisations had no additional knowledge of any association between Lees and the Whitechapel Murders. Shortly after Lees's death, the Society for Psychical Research despatched an investigator to Leicester, who, after a long dialogue with Eva Lees, came up with no evidence, and no facts relating to the story.

With the later resurgence of public interest in the Jack the Ripper case, it would be expected that researchers and authors would have uncovered firm evidence of Lees's involvement. Yet, with the exception of the spiritualist press (and in particular, an item published in *Light*, the journal of the College of Psychic Studies in 1970, which offered a simplified version of the Chicago tale), no writer developed that line of research until Stephen Knight and his revolutionary theory expounded in *Jack the Ripper – The Final Solution*, published in 1976. However, Knight 'cherry-picked' at the old Chicago story in order to support aspects of his own theory, and provided no substantive evidence. His broad theory is also now discredited, yet became the basis for the 2002 film on the subject, *From Hell*.

Do we therefore discount the story in its entirety? Before doing so, researchers will need to investigate more fully the source of Lees's wealth in the 1890s and following decades. Did he receive a Royal pension because of his work on the Ripper case, as his daughter claimed? We must also discover, if it is possible at this distance from the events, who provided the source material for the Chicago article – not the details of the Whitechapel Murders, which were of course freely available, but the more intimate facts about Lees and his family which could only have come from a close friend or a member of the family.

It now seems possible that the Chicago journalists acquired their information from two sources, one being Lees's eldest son, Norman, who was working as a police reporter and visited Chicago shortly before the article was published, the other being the newspaper editor, philanthropist and spiritualist W. T. Stead who was also in Chicago at that time, and knew Lees well.

And we must pare down the whole Lees/Ripper saga to reveal it in its most basic and original form. Then, and only then, we may be in a position to reject the entire hypothesis, or launch ourselves into a new era of research into the identity of Jack the Ripper.

There were a number of separate, but associated, terrorist incidents in London during the Fenian campaign of the 1880s. K. R. M. Short, in *The Dynamite War*, says that the Irish revolutionary Thomas Gallacher played the role of an American tourist in order to plan his dynamite attacks. Short also states that Gallacher first surveyed London in 1882, staying at Rayment's Hotel, at 18 London Wall in the city, and later in

the Charing Cross Hotel. He was arrested on 4–5 April 1883 and sentenced in the June of that year. The trial proceedings were published in *The Times* on 12 June 1883.

Despite Gallacher's imprisonment, the campaign of terrorism continued, and in 1884, an anonymous letter was sent to Scotland Yard that promised the destruction of all the public buildings in London by dynamite on 20 May. On that night in May, a bomb damaged the corner of Scotland Yard and some nearby buildings, including the Rising Sun public house. Coincidentally, Inspector John Littlechild, the Head of the Special Branch at Scotland Yard, escaped injury because on that evening he had chosen to accept an invitation to go with friends to the theatre. Half a mile away, a second device exploded in St James's Square, and a third bomb damaged the basement of the Carlton Club. In each case, the attacks injured innocent bystanders, but failed to cause widespread panic or concern. At the end of the year, a further explosion occurred beneath Tower Bridge, and then in January 1885, what was to be the last attack in the series was within the White Tower of the Tower of London.

Lees's involvement with American visitors to the capital, both in his roles as a tourist guide, and through his spiritualist contacts, provide a partial explanation for Eva Lees's claims that her father came to know about the Fenian plot, and assisted the police in their investigations. There is also a suggestion in Eva's claims of a friendly association between Lees and Dr Robert Anderson, the head of CID at Scotland Yard. In her own mind at least, this provided a convenient connection between Lees and the police investigations into both the Fenian terrorist campaign and the Whitechapel murders.

As with so many of Eva's claims, the Fenian story has had its detractors. This is a quite understandable response to the fact that Eva had a very convenient explanation as to why her father's name did not appear in any police, legal or court records relating to Fenian trials. Quite simply, Eva would tell reporters and researchers, the police had all the intelligence and evidence they needed to secure a conviction without requiring Lees to give evidence.

Melvin Harris attributes the claim that Lees was responsible for the capture in 1883 of Gallacher and his accomplices to Lees himself. He calls it 'another fantasy claim', and presents this as a further reason to mistrust any aspect of the Chicago article. Harris notes that the police were tipped off about Gallacher's plans to bomb London in Birmingham, not in the capital, and that they tracked down the gang's bomb-making factory there. The police gained their intelligence from George Pritchard, a storeman in Birmingham, from whom Gallacher's gang had attempted to purchase glycerine.

However, there were two distinct units operating in the Fenian's London campaign. One group was based in Birmingham and was mainly responsible for the manufacture of the required explosives; the other was based in the capital, in order to plan and carry out the attacks. Eva Lees claimed that her father was in the same London hotel as the gang when the police arrested them. Daniel Black, a spiritualist friend of the Lees family, left his own version of events, which suggests that both were confusing details from different events:

'Lees was one day approached by five gentlemen recommended by a wealthy sugar broker in the USA who desired to have his services for several weeks with the object of being shown architectural points of beauty in all the leading public buildings. Time admitted, however, only of six days being given. The first visit was to be to Westminster, the second to the Tower. Mr Lees had a letter from Gladstone and the Earl of Shaftesbury giving him permission to enter any of the buildings under government control, also a letter from Lord Chelmsford, then keeper of the Tower. The five wanted Mr Lees to spend each evening with them to answer one thousand and one questions, which request met with a refusal. A timely warning reached him from the other side, asking him to report to Scotland Yard, where the officer in charge took him for a madman, as he could get messages 'from the air'.

At the Tower a Beefeater informed Mr Lees there was no-one present but an old woman interested in sketching; if she bothered them he was to get her ejected by a policeman. The old woman followed then and was ultimately put out; on receiving a further warning Mr Lees went to Scotland Yard, where he reported to one of the chief officials, who advised him to return to the restaurant and accept the invitation of the five to dinner, remaining until 8.45pm. The supposed old woman was none other than a detective from Scotland Yard.

At 8.40 p.m. Mr Lees suggested they should go through and read the American news just coming in. Six "Americans" entered at 8.45, then (an)other six. In search of a certain newspaper they finally came round to the table of Mr Lees and found it there, but by that time there were actually two <u>detectives </u>standing behind each of the five tourists.

"You are our prisoners," came the sudden and stern announcement. The trial of Dr Gallacher and his four confederates (American Irish Fenians) terminated in a sentence of twenty years' hard labour – a long term sentence being passed on the others – for an attempt to blow up the Houses of Parliament. The Scotland Yard officials acting on information given by Mr Lees had proceeded to the hotel of the five, and there found the incriminating papers, thus rendering unnecessary any references being made to Mr Lees in the criminal proceedings.'

In the Chicago newspaper article of 1895, Lees is said to be dining with American friends when he experienced one of his psychic visions. There is also evidence of numerous other connections between Lees and American visitors to London. The Chicago article, for instance, also records that at the moment when Lees experienced one of his visions of a forthcoming Ripper murder he was in the company of two Americans at *The Criterion* in London, and their names are given as:

'Roland B. Shaw, a mining stockbroker, of New York and Fred C. Beckwith of Broadhead, Wis, who was then the financial promoter of an American syndicate in London.'

Although the Chicago article is now generally disregarded, it does draw upon many facts and real characters. On 15 May 1895, a young American by the name of J. Chester Lynam wrote to Lees from Chicago. He had obviously read the newspaper article and recognised the name of the man who was cited by the article's authors as being with Lees at the time of his vision. The purpose of Mr Lynam's communication to Lees was solely monetary, because he wished to contact Roland Shaw:

> Dear Sir,
> In an extremely interesting article descriptive of your adventures in the capture of "Jack the Ripper". Mr Roland Shaw, who is spoken of as a mining stock broker of New York, is mentioned as having dined with you at the Criterion at the time of the last murder, and later on to the scene of the murder and still later to the home where the murderer was captured.
>
> Mr Shaw is an old acquaintance of mine, I would very much like to communicate with him, but I have not his address.
>
> May I so far impose upon your good nature as to ask you to hand or forward the enclosed letter to him – I regret that I have not an English stamp to put upon it–
>
> I am, sir,
> Yours very truly,
>
> J. Chester Lynam.

The letter was sent from 2 Washington Place, Chicago, to Lees's address in Peckham Rye, which had been published in the Chicago article. It implies very clearly that Roland Shaw was not a fictitious character.

Further evidence of Lees having been associated with American visitors is given in his article in *Light* in 1886, written as an explanation of events leading up to his re-conversion to Spiritualism. In it he describes a sequence of meetings that had commenced in November 1884 with 'Mr S., a gentleman of some scientific standing, who was also a Spiritualist,' and 'another of the company, Mr B, an atheist.' At one séance, Mr B was apparently told by a spirit to re-open the workings of a certain mine that he had earlier closed, because it still contained valuable minerals.

The nature and validity of these séances is irrelevant, but Lees confirms in the article that over a period of several months, these meetings involved contact – both of a psychic and material kind – with business friends of Mr B and Mr S in New York. It would also seem a remarkable coincidence if these two gentlemen, Mr S and Mr B, were not Mr Shaw and Mr Beckwith.

Another letter exists that would add further support to the claim that Lees was actively involved in passing on information on American Fenians to the authorities. This is in the form of a note signed 'F. Powell' to Lees dated 20 August 1894:

Sir,

I have been directed by Mr Anderson, Director of Criminal Investigation Dept Scotland Yard, to call on you and thank you for your kind offer of assistance re anarchists and to say that he will avail of the offer to the fullest. With this object I am instructed to attend to the matter and would like to see you previous to next meeting night or say at your house at 7 p.m. subject of course to your own convenience. If you can make a more suitable arrangement if you would be good enough to drop me a line I will be delighted to attend to it.

Yours etc.

F. Powell.

The paper on which the note is written has a fold across the centre and appears to have been removed from the centre of a notebook.

The phraseology of this note does not seem to support the view that Lees was ignored by the authorities as a pest or a nuisance, nor that he had no credibility with the police after he contacted them at the time of the Ripper murders. Although it could be argued that any offer of information about Fenian activity would be routinely followed up, the general tone of this letter would suggest that this was not a routine reaction. This appears to be a serious response to a previous offer of information from Lees.

The first specialist department within Scotland Yard's Criminal Investigation Department was set up in 1883 to respond to the growing threat of Irish terrorism. Its first head was Chief Superintendent Adolphus Frederick 'Dolly' Williamson who had previously acted as the senior liaising officer for the detectives in Scotland Yard and the London Divisions. He reported directly to Sir Howard Vincent, Head of the Detectives at Scotland Yard, and to Robert Anderson who was regarded as the Home Office's Fenian expert.

However, Anderson was replaced in this role, and by the time of the Ripper murders he was Assistant Commissioner, CID. The date of Anderson's appointment was 31 August 1888, one day after the second murder attributed to the Ripper.

That the police used undercover operatives in their fight against Fenian terrorism is not disputed. The Metropolitan Police's own official history charts the development of the Criminal Investigation Department and the Special Branch as follows:

Several major crimes and two attempts on Queen Victoria's life roused the authorities to action, and in 1874, two Inspectors and six sergeants were formed into the Detective Department. In 1878 a Director of Criminal Investigations was appointed to head the reorganised Detective Department, which became known as the Criminal Investigation Department. In the 1860s, 70s and 80s public unrest and political agitation made increased demands on the police Confrontations with demonstrators from the rising labour movement and inability to prevent some serious rioting, brought criticisms from various quarters. During this period, the Fenian movement, whose aim was independence in Ireland, was responsible for a series of explosions in London. To combat this threat, the Special Irish Branch was formed in 1883. This

later became known as Special Branch. Its success influenced the authorities to widen its scope to cover security arrangements for Queen Victoria's Jubilee, and later the supervision of aliens, and activities detrimental to public safety and state security.

Again, as is the case with so many alleged incidents in Lees's life, there is strong circumstantial evidence to support most of his daughter's claims, but a total lack of physical evidence. We can confirm that Lees knew many Americans, both visitors to London and those who had made London their own. We know that Lees did have contact with Robert Anderson, and it seems that Anderson, at least on one occasion, took Lees's offer of assistance seriously. We know also that Lees provided philanthropic help to the residents of the East End districts.

According to his friends and family, Lees suffered a period of prolonged ill-health before taking the decision to return to his native Leicestershire in 1928. He was tired, mentally and physically, as he made the journey back to the East Midlands where his dramatic life had begun almost eighty years before. His new home was a modest but impressive-looking house at No. 120 Fosse Road South in Leicester. It is a typical end-of-terrace residence built of red brick with wooden gable windows, and it is of substantial size for a man living on his own. In recent times, as with many similar homes in the area, the building has been extended and converted into student bedsits. There, he was able to keep his independence and maintain his privacy, whilst still being in daily contact with Eva, who lived nearby, at No. 54 Fosse Road South. He was also close to the centre of Leicester, and less than half a mile from the local congregational church.

His travelling days were over, but from his upstairs study in Fosse Road, Lees continued his work, maintaining contact by letter with spiritualist groups throughout the country and overseas. Despite his poor health, he was still able to accept a few preaching engagements at local spiritualist churches. He also continued to write. Eva was to publish a number of his novels posthumously. Other manuscripts, now lodged in the Leicestershire Record Office, include poetry, and the drafts for several dramas and further novels.

From the documents that have survived, it is, of course, difficult to imagine what life must have been like in a house seemingly dominated by such a fervent belief in spirits. Lees regarded his communication with spirits as a natural everyday occurrence. They were not distant intangible ghosts but real entities who occupied the rooms of his home in the same way as did his family.

I have found one remarkable testimony to the nature of Lees's home life in a letter written to me by John Kenneth Riley. John Riley was born in 1920. His great-grandfather was Henry Bishop, who was Lees's father-in-law. Sarah, Lees's wife, was his great-aunt. In a letter written to me in 1986, Mr Riley recounted his memories of his 'Uncle James':

> I am not a spiritualist; my experience with Uncle James in my childhood implanted a fear of Spiritualism in me which has lasted all my life.

I first met him in 1927 when I was not yet seven years old. I was a very sickly child, and had nearly died at birth, and was suffering from a weakness which distressed my mother and father, and they feared that they would never rear me.

I was taken to another cousin's house in Poole, Dorset, where he was staying, and was present when he communicated with the Spirit World. He went into a trance and his body was transformed. He seemed to take on another shape altogether. I was told that he had entered into the body of his Spirit guide.

My father asked him if he would place his healing hands on me, and he agreed to do so. I have never forgotten the experience. He placed his hands on my shoulders and pressed down. I can feel even now the power of his hands passing through me. My spine turned to ice, and it felt as though a thousand daggers were thrusting within me. I was terrified. When he had finished he told my mother and father that there would be no more trouble with my health. He also told them in some detail just what would happen to me in my life, and I must say that all in all he has been most accurate in his forecasts. From the day I saw him I became better, and have lived a very healthy and active life.

There was no doubt that he was an holy man, but I always felt in terror of him. As far as I remember he had grey eyes that penetrated through you. He was short in stature at the time that I knew him, very well built. He was a kindly man and really not to be feared, but his constant communications with the 'other world' meant that to be in a house with him could have some very unusual results. Doors would open by themselves. There would be tappings on the windows. Unseen voices would be heard. Rather like a horror film.

I'm afraid that this is all that I can tell you. There is nothing much new, but I thought that you would like to read a letter from someone who had actually experienced healing from him, and also attended a séance at which he presided.

K. J. Riley.

10 December 1986.

A further indication of Lees's personal beliefs can be gained from several of his later written works, in particular a brief document titled *My Books: How they were written*, the manuscript of which was found after his death. It was subsequently published as part of *The Occult Review* in December 1931.

In this document, Lees is keen to make a precise distinction between spiritual and psychic phenomena, and comments that this distinction is 'not yet recognised as it should be.' He continues in the same vein, declaring that psychic entities may even be 'hampered' by the precautions of scientific watch committees. At the end of his life, and an involvement in matters spiritual that had spanned over fifty years, Lees felt that the world was still only at the very beginning of its adventure into spiritualism:

'Very few of us can say that, at present, we are able to affirm more than a reasonable certainty that the supposed "undiscovered country" does actually exist, and consequently we are sadly ignorant of its real nature, or the laws that govern it.'

The document also provides a brief insight into the way in which Lees and his followers made contact with their spirit friends. His was an open house, and the meetings he held were deliberately informal:

'These gatherings were altogether of an informal character, without any opening or closing ceremony or other approach to an ordinary séance. They were just free and easy friendly talks until some one of our many friends made his appearance known.'

Lees died on Sunday 11 January 1931 at 120 Fosse Road South in Leicester. He was cremated at Gilroes Crematorium, in Leicester, on Thursday 15 January 1931 at 2.30 p.m. As he directed in his will, his ashes were interred at Ilfracombe Cemetery, North Devon, on Saturday 17 January 1931 at 12 noon, where his wife lies buried. Eva continued to live in Leicester at her residence, a short distance from where her father had lived during his final years in Leicester. The house had been presented to her by two spiritualist friends in recognition of help that her father had given them in the past. Eva also continued the publication of her father's work, and the address 'Rodona', 54 Fosse Road South, Leicester appeared on the many books that were printed in the years that followed.

Eva always regarded the time that her father left London in 1895 as the most significant turning point in his life. To her, it seemed that her father had been wronged by those whom he once regarded as friends and confidantes. She wrote a number of obituary articles for the spiritualist press, and in each she spoke in strong terms about the 'suffering' faced by her father in his years of exile in south-west England:

His life was a long catalogue of trials and sufferings – persecuted by those who differed from him; deserted by friends when trouble came; lukewarm support in the hour of trial, ingratitude and calumny. Yet his life was spent in doing good... he literally lived upon love and sympathy, and when for twenty-six years in Ilfracombe he was denied that solace, his health gradually failed and a precious and valuable life faded away in the cold shade of disapproval and animosity.

Despite her strong belief in spiritual resurrection, Eva grieved for her father. In an article published in the *Two Worlds* on 30 January 1931, just days after Lees's death, Eva wrote (of herself):

His eldest daughter, who has been ever by his side to help him in his work since his wife's passing, will always be ready to do her best in giving consolation and help to inquirers.

She will still reside where she can keep intact the 'upper room' in which he worked and spent so many hours in the company of his spirit friends, and she hopes that soon he will manifest his presence amongst us once more.

Meanwhile, she is carrying on such part of his work as she feels capable of...

In 1953, Eva decided to plan for the continuation of her father's work by reviving the Centre for Psychic Research in Leicester. She had first launched this project, with the assistance of Hugh Mogford and her brother Claude, shortly after their father's death. At the time, Eva told the local evening newspaper that 'it is time that Leicester people had the advantage of a psychic research centre on the lines of the Nottingham organisation.' She said that she 'wanted to appeal to the intellectual section of the community, and we are confident that a response will be forthcoming.' She emphasised that the Centre would approach spiritualism purely from a scientific angle and that leading authorities on the subject would be invited to speak. This centre was launched but failed to survive. The two spiritualist churches in the centre area of Leicester, in Lee Circle and Vaughan Way, continued to prosper. A plaque in memory of Lees was dedicated at the Vaughan Way church in August 1965.

The story of Robert James Lees is inextricably bound up with the county in which he was born and the city in which he died. The history of the city of Leicester reaches out to visitors in a way that can be matched by few other English cities. Each street and every footpath tells a story, an almost unbroken narrative from the time of the Roman occupation to the present day. It is therefore a most fitting accolade to the city that the university that bears its name can lay claim to being the founder of the academic study of regional and local history, and that its influence in this field has been significant and has spread widely. In the words of Professor Jack Simmons, one of Leicester's leading historians, it is a town of a long history 'constantly adapting itself to new situations, new demands; but never as a result of violent change, which produces a breach with the past.'

I first encountered the story of Robert James Lees and his turbulent life when I was producing a phone-in programme at BBC Radio Leicester. The general topic of debate was spiritualism but, as with many live programmes of this nature, the discussion occasionally wandered off at a tangent. One caller retold the Lees story and asked if other listeners could tell more.

Afterwards I talked about Lees with Douglas Goodlad, who had formerly edited the *Leicester Chronicle*. In his retirement, Douglas was presenting an old-time music programme for Radio Leicester. He was more than a mine of information about local characters and stories; his knowledge and memory were encyclopaedic and his home resembled the vaults of some vast library, with books and documents stacked high, occupying every spare corner of every room. Douglas told me about a shop known as *Curiotique* and, when he was next on station, showed me a number of cuttings from the *Leicester Chronicle* relating to the so-called Leicester connection with Jack the Ripper, dating back to the time of his editorship.

The front page of the *Leicester Chronicle*, Friday 29 January 1971, offered an 'exclusive' article written specially for the newspaper by Leicester-born author Colin

Wilson. It was titled *Jack the Ripper Unmasked*. In fact, the article was not an exclusive, but recounted the story told to Colin Wilson by the (then) late Dr Thomas Stowell. Stowell's story partly followed the Lees narrative and so was relevant to Leicester Chronicle readers, but it pointed the finger of suspicion towards the Duke of Clarence as the murderer. Stowell's theory had been published in *The Criminologist* less than two months before the *Leicester Chronicle* article and it had gained even wider public exposure with Stowell's subsequent BBC television interview with Kenneth Allsop a few days before the doctor's death.

In the article, Wilson also reviewed briefly the story told by Harold Dearden (in an article in *Great Unsolved Crimes*) about a fellow-officer in the trenches on the Somme in November 1918. The officer's father ran a mental hospital on the outskirts of London. On the evening of 9 November 1888, the man had promised to take his son to the pantomime as a birthday treat. However, his plans were changed by the surprise arrival of a violent and noisy patient who happened to be one of the man's oldest and dearest friends 'a gently demented individual'. Later, the boy decided that this was Jack the Ripper.

As part of the same newspaper feature, Douglas Goodlad reminded readers of the connection with Robert James Lees as the Leicester spiritualist who 'took his secret to the grave.' Regretfully, in doing so, Douglas wandered off well into the realms of fiction:

> Leicester spiritualist Robert Lees claimed he knew who Jack the Ripper was – but he took his secret with him to his grave; and that should have been the end of the matter. Except that when Lees died at his home in Fosse Road South in January 1931, he left behind intact a collection of papers and documents. These are thought to contain his theory about Jack's identity. They were all carefully preserved by his daughter Miss Eva Lees until she died about two years ago. Now they are tucked away in a safe – and a Leicester couple holds the key.

Douglas was guilty of the gross manipulation of the facts. Obviously Lees left behind his papers and documents when he died. He could hardly have taken them with him. It is also true that for many years his daughter Eva maintained his study exactly as Lees had left it, but I can find no evidence that Lees ever claimed *publicly* that he knew the identity of Jack the Ripper.

The papers to which Douglas Goodlad referred, and which were 'thought to contain his theory' hold no such revelations. These same papers were bequeathed to Raymond and Sybil Simpson, two of Eva's spiritualist friends in Leicester after her death. The couple subsequently founded the Robert James Lees Trust, which continued the publication of Lees' spiritualist books for several years. Owing to financial hardship, after ill-health and redundancy forced Mr Simpson to give up work, the papers were put up for auction at Sotherbys on 30 June 1982. The lot failed to reach the reserve price and was offered first to the Leicestershire County Record Office. The County Archivist, at the time, decided not to buy the material, and so the auctioneers then contacted Aubrey Stevenson, the Local Studies Librarian of the Leicestershire Libraries Service.

The papers remained unsorted and un-catalogued in the basement of the Reference Library in Leicester's Bishop Street for several years. When Leicester regained unitary authority status, the collection was transferred, with other locally-relevant material, to the Leicestershire County Record Office in Wigston, a few miles south of Leicester. The collection therefore finally came into the possession of the archive that had earlier declined to purchase it. The collection has now been professionally catalogued (by my wife) and contains a wealth of information about the life, writings and beliefs of Robert James Lees, but sadly nothing directly relevant to any alleged involvement by Lees in the Jack the Ripper investigations.

The Simpsons retained a small number of documents and artefacts relating to Lees which have particular personal value to them. One of the most treasured of this small collection is Lees's bible, with his annotations and margin notes. Further documents were passed to a museum but the location is not known.

Of much greater interest are some papers and documents *not* contained in this collection, including those which found their way into a cupboard behind the counter of *Curiotique* in Wharf Street, Leicester. Again, it was Douglas Goodlad who knew of the clearance of Lees's former home following the death of Eva Lees, and surmised that some interesting material from the house may have survived. Eva had bequeathed her father's library, desk and some other large items to the Spiritualist National Union headquarters at Stanstead in Essex, but as with most house clearances, some miscellaneous items had remained unclaimed and unwanted. These papers, though not offering anything as spectacular as an account of the Whitechapel Murders, do contain many individual papers and correspondence that help to substantiate the story of Lees's involvement.

The former shop that bears the name *Curiotique* is an unusual building, out of character with the surrounding area. In contrast to the dull red brick or grey concrete frontages on either side, this building is almost Tyrollean in character: half-timbered, with white walls, tall narrow dormer windows and dark green shutters. A friend who was born in the area has told me that the building once served as a brothel, one of many which existed in the Wharf Street area. For many years it was at least as well-known as Leif's Pawn Shop. It is just a few minutes' walk from Leicester's shopping centre, the Clock Tower, and the former studios of BBC Radio Leicester where I had met with Douglas Goodlad. I still find it an amazing coincidence that valuable original source material relating to Lees could be located so close to where I was working, and so easily accessible.

One day, quite a few years ago, armed with the promise of a small amount of financial backing from the Leicestershire Library Service, I knocked on the green shutters of *Curiotique*, and was invited inside to explain my mission.

Ten minutes later I emerged with a bulging scrapbook of letters and cuttings of the Lees family under my arm, determined, one day, to write the full story of Robert James Lees.

CHAPTER SIX

The Epic House Haunting

At the heart of many ghost stories is an old building, but sometimes a more contemporary structure gains a reputation for being haunted. If old, half-timbered houses with dark cellars and creaking staircases present the right ambience for the paranormal, then what of a semi-modern office block in the middle of the city?

Epic House is a typical, if architecturally unimaginative, concrete and steel construction of the mid-1960s, standing at the northern end of Charles Street near to the centre of Leicester. It is a familiar landmark recognised by most Leicester inhabitants. The ten-floor tower block stands about 120 feet above a two-storey retail store. It was built in 1965, and the local celebrity and national radio personality, the late Lady Isabel Barnett of the White House in Cossington, performed the opening ceremony. A plaque in the reception foyer above the lift entrances, now covered over by a later refurbishment, records that event.

Originally, the ground floor was occupied by a Safeway supermarket. Later, the premises were used by a discount furniture retailer. The Wilkinson Stores group took over the shop premises in the 1990s and constructed a large extension on the former car park behind the tower on land bordering Clarence Street and Lower Lee Street.

However, it was not on the ground, or even beneath Epic House, in some long forgotten Victorian cellar, that paranormal events have been reported over the past forty years. Surprisingly, all the alleged ghostly happenings in this building have taken place high up in the tower, on the eighth floor.

In 1967, the BBC took out the lease on one floor of the tower block to create a home for Britain's first local radio station. The BBC converted the eighth floor into a broadcasting station, which involved dividing the former open-plan office area into a number of separate rooms including studios, technical areas and offices. BBC Radio Leicester opened on 8 November 1967, with a staff of fifteen.

By 1974, the original local radio 'experiment' had been deemed a success, and the station expanded, taking over part of the ninth floor to house its newly-created newsroom. A decade later, the technical equipment was replaced and upgraded, which involved re-ordering and enlarging the original studios. The shape and size of the studios is an important factor with regard to the testimonies from BBC staff which are to follow.

On an autumn evening in 1972, after the radio station had ended local broadcasting for the day, one member of staff was working late, editing some recorded material for her programme for broadcast on the following morning.

Radio stations are never totally silent. The technical equipment continues to operate throughout the night. At that time, mechanical automatic recorders would start and stop, seemingly at random. Heating systems would switch on and off with thermostat controls. There was the occasional dull 'clunk' of the Gents Pulsynetic pendulum clock in a small room down a corridor, which fed a second pulse to all the clocks in the studios.

By comparison, modern digital radio stations can certainly be quiet and 'cold' places but back in the days of analogue equipment and mechanical devices such as TELEX machines and reel-to-reel tape recorders, there was always a certain level of background noise.

In a sense, the internal noise of a radio station is more apparent because of the high degree of sound insulation in the studios, which is designed for two purposes: to keep out the external sounds of traffic, police sirens, aircraft and other ambient noise that might intrude upon a live broadcast, and to reduce the amount of resonance or 'echo' in the room. If no external sounds can be heard, then the internal noises become more obvious and sometimes more disturbing if they cannot be explained.

The best type of room for a radio studio is one which has little resonance or 'echo'. Every room has a different resonance. In a typical house, the bathroom is usually the most

18 An original BBC Radio Leicester studio in Epic House photographed in about 1968.

19 Epic House, Charles Street, in the early 1970s.

20 Staff at the BBC studios in Epic House, late 1960s. The cupboard that was the focus of unusual activity is on the right.

resonant because, typically, it is a relatively small room with hard shiny surfaces that face each other. Such a room is described as 'lively'. A bedroom is typically a room with much less resonance because it contains materials that absorb sound such as carpet, bedding, quilts, drapes and curtains. Such a room is described by acoustic experts as 'dead'.

So radio studios are designed to reduce resonance, so that they 'appear' to be very 'quiet'. Modern office blocks such as Epic House are rectangular in design and therefore have many 90 degree angles and walls facing each other. So, in order to reduce the resonance on the eighth floor, the BBC in 1967 built rooms within rooms, namely two radio studios accessed only through adjacent control rooms (or cubicles). This created several small corridors-within-corridors, which for some led to a sense of claustrophobia as heavy sound-proofed doors could close silently behind you and leave you cut off from the outside world.

On this night in 1972, the producer of the daily 'Coffee Break' programme was working in what was then known as Cubicle 2. It was a small control room that was associated with Studio 2, the two areas being used mainly for pre-recording programmes. The presenters and other contributors would be placed in the studio whilst the recording engineer, known then as a Station Assistant, would control the microphones and tape recorders in the cubicle, communicating by a form of sign language through the glass partition, but also using a talk-back system which enabled the presenter to receive instructions in headphones.

It was mid-evening and the street lights outside were just turning on. The view from studio and cubicle could be breathtaking at times, especially at sunrise and sunset. At dusk, however, the side of Epic House occupied by the studios would be in darkness first, as it was the other side of the building that faces across the city towards Bradgate Park and the setting sun.

Because of the sound insulation, the windows were boxed in by a type of thick double glazing, and in those days there was no air conditioning. The room was therefore very warm, heated by the residual heat rising from the valve amplifiers mounted below the two tape decks.

The producer reported that suddenly the room felt very cold. The chill seemed to radiate outwards from a large dark brown wall-mounted cupboard, the only fixture in the relatively small room. Later, the same member of staff noted some indistinct noises from the vicinity of this cupboard, but she was unable to add any further information. By that time she was on her way down the eight flights of stairs to her car in the car park behind the building.

Almost twenty years later, a young radio journalist was working late at the station when a similar event took place. In the intervening years, the earlier producer had left the BBC. The younger journalist had never met her and did not know her name, and was unaware even of her existence. Additionally, the radio station had been refurbished some years previously. The earlier producer would have found it difficult to navigate the new corridors and rooms, just as the new journalist would have found the old layout confusing.

The earlier configuration of two studios – accessed through two adjacent control areas or cubicles – had been replaced. The four original rooms became three larger

rooms with a central technical and operational area and two studios, one on each side. So the former Cubicle 2 area had become part of the new larger Studio 1b.

During the extensive rebuild, in which whole walls were removed and rebuilt and a record library containing more than ten thousand vinyl long-play records was moved an entire floor, just one piece of built-in furniture was left in place – the dark brown cupboard in which the station's precious archive recordings were stored. Now, this cupboard was in the corner of Studio 1b rather than occupying the entire north wall of the old Cubicle 2.

On this night, the room again became very cold. Later – much later, because the young man felt that his journalist colleagues were unlikely to believe his story – he spoke of his fear and unease. There was nothing tangible. Nothing that he could describe in any objective way. Nothing that he could write down as a reporter is able to write down and record emotions, events and feelings. But this was the same place, the same space, and very similar sensations, twenty years on.

There is no explanation. In 2005, BBC Radio Leicester moved to new premises in St Nicholas Place, near to the medieval Guildhall and in the heart of Roman Leicester. Back at Epic House, all the dividing walls were ripped out and the furniture removed, including the old dark brown cupboard, which was possibly the only fixture that survived the entire thirty-seven years that the BBC occupied the building. The wooden panels were taken down to a skip in a car park behind nearby Bedford Street and carted away.

No explanation, but some very interesting contextual facts arise. The area between Belgrave Gate and Clarence Street has been an ever-changing townscape since early Victorian times. Epic House was built on the site of the former Leicester (or Leicestershire) horse repository, which was near to the old route into Leicester from Newark and Lincoln, Loughborough and Nottingham. Charles Street was constructed in 1932 as a bypass to remove traffic from the clock tower area of the city. Originally, traffic to and from the north would have passed this location en route to the Haymarket and the East Gate of the town, near to where the Victorian clock tower now stands.

The original repository – a building in the Victorian Gothic style – stood on a nearby site in Belgrave Gate, close to the present roundabout, which is the junction of Belgrave Gate, Charles Street and Bedford Street. At one time, the junction where Belgrave Gate and Bedford Street meet, and just a short distance from Lee Street and Hill Street, was the gateway into the Wharf Street area of the town. This was a network of small streets and courts where, in Victorian times, thousands of people lived in poor conditions, in back-to-backs and in even more squalid tenements that could be reached only through dark alleys.

As a business, the history of the repository dates back to 1875. For twenty years before that, a paddock adjoining the ancient Bell Hotel on Humberstone Gate had been used for the same purpose, the buying, selling and stabling of horses. The building in Charles Street replaced this earlier repository when the new route avoiding the clock tower and Gallowtree Gate was created. It was completed in 1930, and opened formally on the first day of the famous Leicester Pageant. The newer repository was

designed by the Leicester architect Clement Copeland Ogden, whose practice was located in Friar Lane.

The purpose of the repository may have changed somewhat over the years, but one can imagine that at some time, the incoming stage and mail coaches would have changed their horses here. In a similar way to a modern services area, various ancillary businesses would have clustered around the repository, including a public house which also offered overnight accommodation. This hostelry was originally called The Horse Breaker's Arms but later become The Repository Hotel.

In earlier times, Joseph Merrick, the 'Elephant Man' worked here as a boy of about twelve, hand-rolling cigars for a tobacconist in Hill Street, until his deformities meant he could no longer undertake the task with the necessary degree of accuracy and neatness. Merrick was born in the next street, Lee Street. The tobacconist's shop faced Hill Street, now the pedestrianised Lower Hill Street, and was located approximately where the reception entrance for Epic House now stands. Although the repository at that date was in Belgrave Gate, no doubt the tobacconist drew much of his trade from the men who stabled their horses there. The final owners and operators of the repository were Warner, Shepherd and Wade who were well-known auctioneers in Leicester until recent times, the original site having been purchased by George Tempest Wade in 1875. The later repository was finally demolished in March 1962.

The more that paranormal investigators research the past history of a site, it stands to reason that it is more likely that some association with the afterlife will be discovered. In the case of Epic House, this research needs to return to period of the Roman occupation.

In the summer and autumn of 2001, before the extension to the ground floor retail store was built, a detailed archaeological survey of the car park next to Clarence Street and behind the tower was carried out.

The site lies to the east of the Roman town defences, in an area previously identified with Roman cemeteries. The excavations revealed the most easterly remains of a Roman cemetery. Sixty-two inhumations were discovered. A number of earlier Roman features were also excavated, which included some substantial domestic and industrial pits. A later monitoring and recording exercise revealed a further thirty-three Roman inhumations and one earlier pit.

All the burials were on a west–east orientation and the bodies had been laid in their resting place on their backs. They were lacking grave goods and a number were in nailed timber coffins.

There are no other documented reports of paranormal events in Epic House, and no useful stories of an individual here who was murdered or who met and untimely or gruesome death. There are just the separate and independent testimonies of two very down-to-earth real people; testimonies that are so similar that coincidence must be ruled out.

A Ghost Walk Through the Old Town

The best way to experience and savour the atmosphere of the oldest area of Leicester, where it is claimed there are many haunted buildings, is on foot along the cobbled paths that still exist and which connect many of the city's most ancient buildings.

There are three distinct areas along this walk, these being the Castle, the Newarke and the old town itself. Some of the original walls and gateways that were built to define these areas can still be seen today.

On this walk, you will pass by a number of buildings that are allegedly haunted. Some are easily accessible and are open to the public on a regular basis. Others are private or have restricted access, but there are many opportunities for a glimpse of a dark corner through railings and windows.

This walk begins in Castle Street, which is a small turning off St Nicholas Circle near to the side of the Holiday Inn. If you choose to visit this area by car, you can park in the St Nicholas Circle multi-storey car park or the smaller Lanes surface car park in St Nicholas Place. St Nicholas Circle is a pay-and-display car park where you pay on exit. If you park before 9.00 a.m. lower charges apply. In the Lanes car park you will need to pay in advance, which means deciding in advance how long you plan to take for your walk. This is a circular walk and can be completed easily in less than one hour. You can also retrace your steps at any time. To take advantage of opportunities to look inside several of the buildings you will need to allow more time.

There are also several free parking spaces on Castle Street where you can park for up to one hour. You can also reach this location by taking one of the frequent Park & Ride bus services. These all terminate in St Nicholas Place.

1 – Walk down Castle Street to reach the church of St Mary de Castro, with the entrance to Castle Park on your left

Black Annis, Leicester's most famous witch, is said to haunt the church of St Mary de Castro, as well as the surrounding graveyard and pathways.

This is one of Leicester's most beautiful churches, and it has a very long history. Robert de Beaumont, the powerful English and French nobleman who had

21 The Judge's Lodgings near the castle.

accompanied William the Conqueror to England in 1066, founded the church in 1107. He had been gifted the castle and its surrounding land by King Henry, who had retrieved them from an unruly owner. Possibly a Saxon church of St Mary existed on this site before the Norman Conquest, which Robert de Beaumont rebuilt.

It is said that Robert died of shame after 'a certain earl carried off the lady he had espoused, either by some intrigue or by force and stratagem.'

The name of the church literally translates to 'Mary of the Castle', a title that was given to differentiate the church from the Leicester Abbey, which is known as 'Mary of the Meadows'.

The church has a remarkable oak ceiling, located in the south transept, and boasts some of the most exquisite woodcarvings to found anywhere in England. The tower and the spire were added to the roof in 1400. However, the original spire had to be replaced in 1783 after it had been struck by lightning and damaged beyond repair.

St. Mary de Castro has always been associated with the claim that the writer and clerk Geoffrey Chaucer was married in the church in 1336 to Phillipa Roet, a lady-in-waiting to Edward III's Queen, Philippa of Hainault, and a sister of Katherine Swynford who later, in about 1396, became the third wife of Chaucer's friend and patron, John of Gaunt.

King Henry VI was knighted within the church walls. The ceremony took place in 1426 when he was just a small boy and at the same time that the Parliament of Bats was being held in the castle. The 'bats' were not the winged variety, but bats as in clubs and sticks. Due to national political tensions, the Parliament was held in Leicester

rather than in London, and those attending brought these crude weapons because the Duke of Gloucester had outlawed the carrying of swords.

2 – Outside St Mary de Castro, turn into Castle Gardens

The River Soar at this point was straightened as part of major flood defence work in the nineteenth century and later, and this section is now called the Mile Straight. Standing on the tow path by the side of the Straight, looking across to the refurbished Pex building, we are now very close to the beginnings of Leicester as a settlement.

It was the then slow and lazy waters of the River Soar that brought Leicester into being, and belief in the entity of a water goddess that possibly gave Leicester its name.

The very earliest legends and myths were associated with the natural features of the landscape and were often connected with rivers. Rivers were incredibly important to our earliest ancestors. They could provide water, food, a means of defence and protection from attack, and were one of the few ways of defining where your settlement was located.

The River Soar was previously known as the Leir, a name probably derived from *Ler* or *Llyr* , the Celtic name for a water god, more-or-less similar to the gods Poseidon or

22 Castle Gateway

Neptune in Greek and Latin myths. The Celtic name for a settlement by the side of the Leir would have probably been Caer-Leir, translated by the Saxon (as in the tenth century) as *Legra-ceastar* and in the Domesday Book as *Ledecestre*.

The main tributary of the river ran to the east of the river valley, with a secondary stream to the west, and this separation created a marshy island between. Possibly, the earliest people to find this small island followed the tracks created by generations of migratory animals through the surrounding dense woodland, and again, possibly, the tribes who were to settle here in the late Iron Age constructed fords across the shallowest part of the river, close to the present West Bridge.

Collectively, these people were known – at least to the Romans – as the *Corieltauvi*, and before the invasion of AD 43 they occupied the area of the East Midlands roughly approximating to the region represented today by the counties of Leicestershire, Lincolnshire, Nottinghamshire, Rutland and Northamptonshire.

The *Corieltauvi* were an agricultural race who tended to settle in lower and more fertile areas, usually beside streams or rivers. They had few strongly defended sites, generally not relying on hill forts for protection, but making use instead of forested landscapes to provide cover and protection. However, the Romans were to call the town *Ratae*, an early Celtic word meaning 'ramparts', suggesting that when they reached the area they found some buildings of a defensive nature.

This would mean that there has been a defensive structure on this site for more than two thousand years. The earliest 'castle' was of the motte-and-bailey type, and Leicester's motte, a large mound of earth about forty feet in height, still survives nearby. Originally, it would have been even higher with a wooden tower on the summit, and it is likely to have been built in 1068 by the king and subsequently handed over to the most important Norman landowner in the area, Hugh de Grentemesnil. It was probably placed here in the south-west corner of the town to take advantage of the surviving Roman walls to the south and west as well as the defences provided by the river.

The motte was lowered in the late nineteenth century to form a bowling green for the Castle Inn, which has now been demolished. You can reach the motte from Castle Gardens.

This area between the castle and the river was formerly a rubbish dump used by the old Leicester Corporation. It was opened as a garden so that remaining fragments of the castle's boundary wall could be seen.

3 – At the lower end of Castle Park, near to the bridge, see the statue of King Richard III

No other English Monarch attracts such devotion from his followers than Richard III, the last English king to die in battle. Certainly he has a strong association with the town of Leicester. Legend has it that his death on Bosworth Field on 22 August 1485 was foretold by an old witch who cackled her prophecy to him as he rode out at the head of his army over the Bow Bridge, which was located very close to this point.

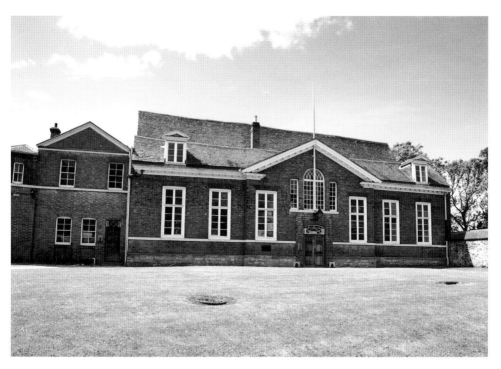

23 The castle and castle yard where executions took place.

As his spurs scraped against the stone parapet of the bridge she told him that on his return, it would be his head that scraped the same place. It is said that when Richard's body was brought back to the town, slumped face-down over a horse, the cold crone's prophecy came true.

Richard's body was then exposed, possibly in the now lost Church of the Annunciation of Our Lady, which was located in the Newarke. According to some sources it was then hanged by Henry Tudor, then King Henry VII, before being buried in or near the Church of the Greyfriars. Some evidence suggests that a memorial stone was visible as late as 1612 in a garden built on the site of the Greyfriars.

It is said that, in 1495, Henry VII paid fifty pounds for a marble and alabaster monument. According to another tradition, during the Dissolution of the Monasteries, Richard's body was thrown into the River Soar near here. There is currently a memorial plaque on the site of the Cathedral where he may have once been buried. These are all sites that we visit during this walk.

The statue of Richard is by the British sculptor James Walter Butler RA (1931). It is made in bronze, and was unveiled on 31 July 1980 by Princess Alice, Duchess of Gloucester. It had been commissioned and contributed by members of the Richard III Society and celebrates Richard's birth (at Fotheringhay Castle in 1452), his reign as King of England (from 1483 until his death) and his death at the Battle of Bosworth.

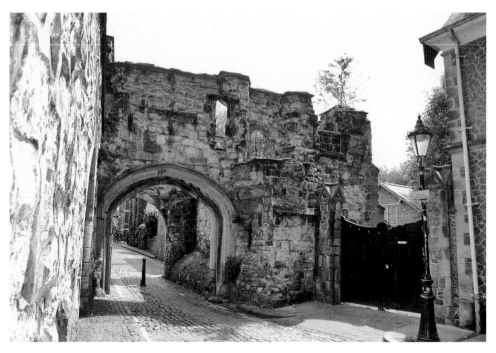

24 The Turret Gateway and Castle View.

4 – Retrace your steps back to St Mary de Castro and turn left through the half-timbered gateway into Castle View, Castle Yard and the Castle

This now quiet corner of Leicester, the Castle Yard, flanked by the church and the castle, has seen many turbulent events and much suffering of individuals over the centuries. For many years, it was used for public executions. On a more uplifting note, the Methodist pioneer John Wesley preached to 'a great crowd here' in 1771.

The cells of the Great Hall have witnessed many turbulent scenes, some of which appear to have left an imprint on the cold atmosphere. The sound of cell doors banging shut has been reported on many occasions, as well as arguments between invisible inmates. Staff at the hall would often complain of bells ringing from the cell area when they were empty. Other visitors have heard heavy sobbing noises in the upper areas of the main building, many years after the castle's hall had ceased to be a court of law.

There is an underground space here known as John of Gaunt's cellar. It is a fifteenth-century room that runs under the courtyard next to the hall. This long, dark, subterranean chamber measures about fourteen metres in length and six metres in width, and was built of large sandstone blocks. The ceiling is of ashlar masonry with a four-centred tunnel vault, and there is a beaten earth floor. Many of the ashlar blocks display the marks of the masons who worked on its construction.

In 1265, the castle was granted to Edmund, Earl of Lancaster and Leicester. Throughout the thirteenth and fourteenth centuries, the earls and dukes of Lancaster continued to use Leicester castle as a residence and as one of their chief administrative centres. The prison in the castle is first mentioned in 1298, when it was being used for the detention of prisoners taken on the earl's lands. It is last mentioned in documents in 1323.

Many a death penalty was handed down within the castle's walls over the centuries. It was still being used as an assize court in the latter decades of the twentieth century, a practice dating from at least 1273.

5 – Follow the cobbled path towards the Turret Gateway

Here is one of the most infamous locations in the legend of Black Annis. There are many different versions of the story, which generally tells of the witch waiting in the shadows of the turret gateway until children passed by. At midnight, she would extend her long arms and fingers and grab them from the path.

This ancient and now-ruined gateway was built in 1422/23 to connect the castle enclosure with the Newarke. It was built originally with three stories, and had an entrance and lodge on the ground floor and a portcullis chamber and other rooms in the upper storey. It was partially destroyed in an election riot in 1832, when the top

25 The herb garden behind Trinity House.

storey was demolished. Fireplaces are visible on the upper floor. The stonework on the arch was restored during the 1980s and is still being worked on today.

A section of the castle wall, next to the gateway, has gun loops (holes) that were poked through the medieval wall to use as firing ports by the inhabitants of the town when parliamentarian Leicester was besieged and consequently captured by the royalist army in the 1640s.

James Thompson, in his account of Leicester Castle which he wrote in 1859, alluded to underground areas beneath the gateway:

'Beneath the building are chambers and passages, as yet unexplored, and their purposes therefore undiscovered. That there may subterranean means of communication between the Mount, this gateway, and other localities in the Newarke, is a conjecture founded on tradition, and not to be entirely and superciliously rejected.'

6 – Castle View opens out into Magazine Square, but just before, enter the gardens behind Newarke House Museum and go through the small gate on your left

You are now standing in the yard and garden of Wyggeston's Chantry House. This is another of Leicester's haunted buildings.

26 The Turret Gateway and Newarke Wall with the spire of St Mary de Castro.

This dark, ivy-clad building was built in about 1511/12 by William Wyggeston, who was Leicester's richest citizen of that time and its greatest benefactor. It was used as the residence of two chantry priests who sang masses for his soul in the nearby church of St Mary of the Annunciation.

Historically, this building is of immense significance as it is the only Elizabethan urban gentry house in the country.

The house has had many occupants over the years, and it has also undergone many structural changes including the addition of a third floor in the sixteenth century. It was used mainly as a private dwelling until 1940 when it was damaged by bombing during the Second World War. For some time at the beginning of the twentieth century it was used as an office by one Henry Lovatt, who was the director of the company building the Great Central Railway through Leicester.

Given its motley collection of previous occupants, no-one is able to identify with any certainty the figure in a long dark cloak that has been seen on numerous occasions at the top of the main staircase walking towards the window. In recent times, when some repairs were being made to the building, a postcard holder rotated on its own, throwing all of the cards out on the floor. This particular figure sometimes strays into the adjoining houses, which are all part of the Newarke Houses Museum.

Here he is joined by another male figure, this time in Elizabethan style costume. The man appears from the wooden panelling in the Gimson Room and then disappears through an adjacent wall. A mysterious shadow, with a human form, has also been seen in the area. On several occasions, a member of staff has stepped to one side to allow a figure through, only to realise that no one was present.

The different sections within these gardens demonstrate some of the features of English gardens through the ages and the Castle Wall Border includes many plants that were associated with myth, religion and superstition.

Feel free to explore inside these buildings, which are open daily, free of charge. If you have time, walk through the box-hedged garden to take a closer look at the boundary wall and the ruined end wall of the turret gateway. The holes in the wall can be seen clearly.

7 – Magazine Square, the church of St Mary of the Annunciation in the Newarke and the Newarke or Magazine Gateway

The frontages of Newarke Houses Museum face Magazine Square, which is now at the centre of De Montfort University. Standing near the two cannon in the front gardens of the museum, you may be able to imagine a medieval college complex of considerable size, with a fine church to your right and other smaller monastic-type buildings around you.

The church of St Mary of the Annunciation stood here, partly beneath where the university's red-bricked Hawthorn Building now stands. In the basement of one wing of the Hawthorn are some stone arches and other masonry, which is all that has

27 Wigston's Chantry House. The rear entrance.

survived of this church. The very modern university Law building directly opposite is named after Hugh Aston, a former mayor of the town who was also the director of music of the college. Several members of the important Wyggeston family lie buried here, including the man who built the Chantry House.

In the nineteenth century, an underground passage was discovered beneath this square. It runs from Trinity House, which was formerly a hospital (or 'almshouse') to the college, in the direction of where the church may have stood.

The Magazine Gateway on your left is a medieval gateway added to Leicester Castle by the Third Earl of Leicester in about 1410. The upper floor is divided into two large rooms with a huge fireplace on the left side. There is a spiral staircase that leads to the upper floor.

8 – Turn left and walk along the path to the pedestrian crossing. Cross over the road and turn left towards the Shakespeare Public House. Keep the pub on your left to reach Peacock Lane

We are now inside the medieval town of Leicester as opposed to the Castle precincts and the Newarke, which were both outside the town and not subject to the town's regulations.

28 The Turret Gateway from the gardens of Newarke Houses Museum.

This may be described as the haunted heart of the town. You have just walked the length of Southgate, which led from the old south gate of the town towards Highcross Street. This was Leicester's original High Street, the spine of the medieval town and on a close alignment with the Roman street that ran from north to south through the centre of the Roman settlement, skirting the length of the forum.

This section of Highcross Street is now pedestrianised and has been renamed Applegate, a rather confusing name as it is nowhere near the area of the town – just outside the east gate – where the Danish street names (Gallowtree Gate, Belgrave Gate, Humberstone Gate, Churchgate and Belgrave Gate) are to be found. In medieval times, there was an Applegate Street near where the Holiday Inn now stands, but this renaming of Highcross Street is both confusing and erroneous.

9 – St Martins House

To your left is Wyggeston's or Roger Wigston's House (which we shall visit shortly) and to your right, St Martins House, the former Wyggeston's Boys School. Beneath the new car park, which was formerly the school playground, are subterranean rooms that were used by successive schools occupying the site as changing rooms. A ghost of a Roman centurion is said to march through this area following the line of a Roman street.

29 Section of the Newarke Wall behind Newarke Houses Museum.

30 Magazine Square and De Montfort University's Hugh Aston Building.

10 – Turn right and walk across the south side of St Martin's Cathedral and graveyard. Then turn right again into the narrow New Street directly opposite the path from the cathedral

New Street still has the atmosphere of Georgian England with its facades and frontages, which are full of character. This is a street of solicitors as, until the recent worldwide financial downturn, many famous Leicester legal firms had their headquarters here.

New Street cuts into the former land of the Grey Friars. John Leland, the sixteenth-century antiquary and historian, writing before 1543, says 'the Greyfriars of Leicester stood at the end of Wigston's Hospital and there was buried King Richard III'.

Wyggeston's Hospital stood, until 1875, on land beside the cathedral, in line with the cobbled path known as St Martin's West, on what is now the car park of St Martins House. So according to Leyland, Richard's grave may be close by.

Immediately to the right as you enter New Street is the entrance to a car park behind the houses and offices that front Peacock Lane. Part of the boundary wall that divides the rear yards of those buildings with the car park is all that remains of the original medieval wall of the Greyfriars. It is marked with white paint and graffiti, and is surrounded by litter and other rubbish, but it is still there.

The car park attendant is usually willing to allow visitors access to the wall, which is just past his wooden hut.

There is clear evidence that the numerous cellars beneath your feet and under the buildings of New Street and the remainder of the Greyfriars area were once connected, and that it was possible to walk under this area towards the Cathedral, the Guildhall and beyond.

11 – Retrace your steps back to the Cathedral and take the narrow cobbled path known as St Martin's East, keeping the Cathedral on your left into Guildhall Lane and Silver Street with the Opera House bar on the corner

The actual Royal Opera House was located a little further down Silver Street. It survived as a live theatre until the late 1950s and was demolished promptly after its last performance in 1960. In its place Samuel Locker built the Malcolm Arcade of shops, being named after his son Malcolm who died in the war.

The building on the corner of St Martin's East and Guildhall Lane is also referred to as The Opera House and is presently open as a Champagne Bar, having been a restaurant. Both this and the theatre are said to be haunted.

12 – The Cathedral

Leicester's modest but delightful cathedral is well worth a visit and always welcomes visitors. Most of the present building is Victorian, but much older structures can be

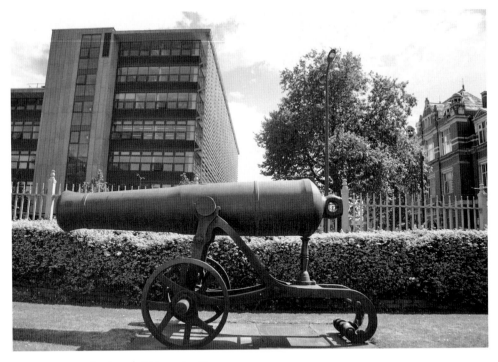

31 Cannon at the front of Newarke Houses.

32 The Chantry House.

found, and indeed the original St Martin's Church was one Leicester's earliest places of Christian worship.

Are there tunnels beneath the cathedral? Was Richard III's body placed here for some time, or buried here?

13 – The Guildhall

We reach the hub of haunting in Leicester. The Guildhall claims to be the city's most haunted habitation.

The Guildhall is one of the best preserved timber-framed halls in the country, dating back just over six hundred years. The building – or collection of buildings, as the original hall has been extended and added to over several centuries – has had many uses and lives. The Great Hall itself was built in about 1390 as a meeting place for the Gild of Corpus Christi, which was a small but powerful group of businessman and gentry.

Over the next hundred years, the Great Hall was extended. Two wings were also added at either end.

By the end of the fourteenth century, the power of the Gild was in decline, but many members of the Gild were also leading figures in the governance of the town. The Corporation of Leicester had begun to meet in the Guildhall with many of the

33 Greyfriars. The remaining fragment of medieval wall behind Peacock Lane.

members of the Gild in attendance, so when the Gild was finally dissolved in 1548 the Corporation bought the buildings for the sum of £25 15s 4d.

In 1632, the Town Library was moved into the East Wing of the Guildhall from St Martin's Church. The Guildhall is now the home of the library of the Leicestershire Archaeological and Historical Society which has used this building as its formal 'home' for many years. Also in the middle of the seventeenth century, the ground floor of the West Wing was refurbished as the Mayor's Parlour.

The Great Hall was often used as a courtroom, so a Jury Room was created above the Mayor's Parlour. The Guildhall was also used regularly for theatrical performances, banquets and civic events. There is a longstanding belief, yet to be proven, that William Shakespeare once performed here.

With the growth of the town and the expansion of local government functions in the nineteenth century, it became increasingly apparent that the Guildhall was too small to serve as a Town Hall for the future. A new Town Hall was built on the site of the ancient Horse Fair and opened in 1876.

For the next fifty years, the Guildhall was used for several purposes including as headquarters of the local police and a school. It fell into disrepair over many years of neglect, but was finally renovated and opened as a museum in 1926.

Fortunately, the council decided to restore the building and, following a major renovation programme, it was opened to the public as a museum in 1926.

This is a place where the visitor can step back in time. There are few set pieces. The building's antiquity is well capable of speaking for itself, but down in the area of the cells one will come face to face with 'Crankie Gemmie' and 'Emma Smith', two of Leicester's notorious pickpockets.

These are the physical personages of the Guildhall. According to both staff and visitors, and a host of paranormal researchers, there are many more very interesting occupants.

14 – BBC Radio Leicester Undercroft

Opposite the Great Hall of the Guildhall, on the other side of Guildhall Lane, are the very modern studios of BBC Radio Leicester, constructed in 2004. The building is undeniably of the twenty-first century but its design allows the Guildhall light and space. It also includes a very old undercroft, which was incorporated into the new building's structure.

The BBC studios are situated on land formerly occupied by a Victorian warehouse where cigars were once packaged along with wine, port and cheese. This building had been constructed by the local company of Swain and Latchmore in about 1840. At the time of the construction, an undercroft dating to the twelfth century was exposed, and photographs were taken of the stone and brick work beneath.

Remarkably, structures beneath ground level have survived, and were investigated by archaeologists in 2003 when the old Victorian building was demolished. Roman, Norman and later structures were found, indicating a long period of occupation.

34 St Mary de Castro from Castle View.

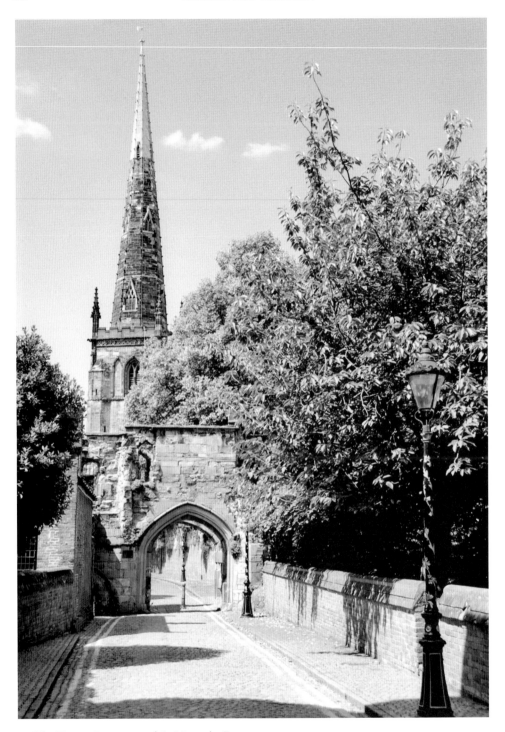

35 The Turret Gateway and St Mary de Castro.

15 – At the front of BBC Radio Leicester, Guildhall Lane joins St Nicholas Place, formerly Highcross Street

The corner of the plot – where the Clockwise Credit Union has its offices – marks one of the most important early crossroads in Leicester, being the intersection of the main street linking the north and south gates of the town, and the principal east–west route through the town, which we know as the Fosse Way.

16 – Roger Wyggeston's House

On the opposite side of the road is Wyggeston's House, a marvellous Tudor town house which has survived largely because it has been protected by a later building, which was constructed in front of it facing the street. It is no longer open to the public, but it is most certainly high up on the haunted list.

The most disturbing of sightings was made when the building was in use as the city's costume museum. A member of staff saw the ghost of a small child on the stairs, crying and sobbing hysterically. The museum assistant came in early one morning and could hear the child crying. She went outside to see if someone was lost but, finding nothing, returned inside. Looking over at the stairs, the figure of a boy of approximately twelve years of age in Georgian costume appeared, kneeling down and crying.

This figure, which may be in Georgian or later Edwardian clothes, has frequently been seen, though more often heard. The sound of a ball bouncing down the stairs has often been heard. Furniture is moved around and the vacuum cleaner has sometimes been unplugged during morning cleaning sessions.

This small boy often appears when other children are present, and in recent years the building has been used as a centre for young people. On one occasion, he was seen in the former drapers shop at the rear of the building by another boy who immediately contacted the duty staff and described the ghost. This description was exactly as the staff had witnessed, including knickerbockers and a waistcoat with a grey and blue transparency.

Follow the pavements to the pedestrian crossing to return to your car or catch a Park and Ride bus

Acknowledgements
and References

Many of the locations listed in this book are in private hands, and I must therefore thank their owners and those who look after these buildings for their co-operation during my research.

I must also acknowledge the enthusiasm of all the staff of the Leicester Museum Service at the Guildhall, Newarke Houses and Belgrave Hall. The Museum Service arranges frequent events that touch upon the paranormal including talks, ghost walks and night vigils.

My grateful thanks must also go to all those individuals, friends, colleagues, shopkeepers, pub landlords and local historians who have mentioned specific events and relevant facts to me.

There are many general histories of Leicester that provide background to the city's older buildings as well as referring to some of the legend and folklore of the area.

Black Annis, *Leicestershire Legends Retold* (Heart of Albion Press: 2004)

Ellis, Colin D. B. *History in Leicester* (City of Leicester Publicity Department: 1948)

Hamilton Thompson, A. *The History of the Hospital and the New College of the Annunciation of St Mary in the Newarke, Leicester* (Leicestershire Archaeological Society, 1937)

The Legends, Folklore and Dialect of Leicestershire with an Introduction on the General History of the County by Lt-Col. R. E. Martin when he was Chairman of Leicestershire County Council, and based on two radio talks given on the BBC in 1933, is also available in the Transactions of the Leicestershire Archaeological and Historical Society.

Thompson, James, *An Account of Leicester Castle*, is a rather romantic description of the history of the castle. (Originally published by Crossley and Clarke: 1859, reprinted by Sycamore Press Ltd: 1977)

Trubshaw, Bob, *The Making of a Legend: Black Annis and her Bower*, in Transactions of the Leicestershire Archaeological and Historical Society, 80 (2006) pp43-59

Skillington, S.H. *A History of Leicester* (Edgar Backus: 1923)

Wright, Andrew James, *Haunted Leicester* (The History Press: 2005)

Wright, Andrew James, *Ghosts and Hauntings in and around Leicester* (Heart of Albion Press: 2006)

Leicestershire People and Places – One Hundred Years Ago, Heart of Albion Press, 2010. This is a fascinating selection of photographs by the Leicester photographer and artist George Moore Henton, with text by Anthony Wibberley

Articles in the Transactions of the Leicestershire Archaeological and Historical Society provide more detail on specific locations, periods and activities. These are available in the Record Office for Leicester, Leicestershire and Rutland, and many can now be downloaded from the Society's website.

The archaeological excavations relating to the undercroft beneath 9 St Nicholas Place are recorded in the Transactions (TLAS), Vol. 84, 2010.

List of Illustrations

1 St Martin's East. The cellars of the building on the corner of Guildhall Lane are said to be haunted.
2 St Martin's East, looking past the former Provost's house towards Peacock Lane and the Greyfriars area.
3 The showrooms of Thomas Herbert Wathes in Highcross Street, formerly a Cigar Manufactory and now the site of BBC Radio Leicester's studios.
4 The undercroft beneath the BBC studios at the rear of 9 St Nicholas Place, photographed in 1861.
5 The churchyard of St Peter's, Belgrave.
6 The Nave and Chancel of St Peter's Belgrave in about 1920.
7 The infamous Talbot inn in Thurcaston Road, Belgrave.
8 The Talbot Inn, in 1873, before the upper floor was removed.
9 Belgrave Hall viewed from the gardens.
10 Closed-circuit television equipment overlooking the gardens at Belgrave Hall.
11 The staircases and first-floor landing in Belgrave Hall.
12 An image by the spirit photographer Charles Boursnell from about 1900, of Robert James Lees and an alleged spirit friend.
13 Robert James Lees's final home in Leicester in Fosse Road South.
14 The Queens Head in Bond Street, Hinckley. Lees was born in the upper room of the small building on the right of the pub.
15 Robert James Lees, photographed in about 1875.
16 A classic portrait of Robert James Lees, taken in about 1920.
17 The diary of Robert James Lees for September 1888, in which he refers to the Whitechapel Murders.
18 An original BBC Radio Leicester studio in Epic House photographed in about 1968.
19 Epic House, Charles Street, in the early 1970s.
20 Staff at the BBC studios in Epic House, late 1960s. The cupboard that was the focus of unusual activity is on the right.
21 The Judge's Lodgings near the castle.
22 Castle Gateway

23 The castle and castle yard where executions took place.
24 The Turret Gateway and Castle View.
25 The herb garden behind Trinity House.
26 The Turret Gateway and Newarke Wall with the spire of St Mary de Castro.
27 Wigston's Chantry House. The rear entrance.
28 The Turret Gateway from the gardens of Newarke Houses Museum.
29 Section of the Newarke Wall behind Newarke Houses Museum.
30 Magazine Square and De Montfort University's Hugh Aston Building.
31 Cannon at the front of Newarke Houses.
32 The Chantry House.
33 Greyfriars. The remaining fragment of medieval wall behind Peacock Lane.
34 St Mary de Castro from Castle View.
35 The Turret Gateway and St Mary de Castro.

Leicester Through Time
Stephen Butt

This fascinating selection of photographs traces some
of the many ways in which Leicester has changed
and developed over the last century.

978 1 84868 252 8
96 pages, full colour

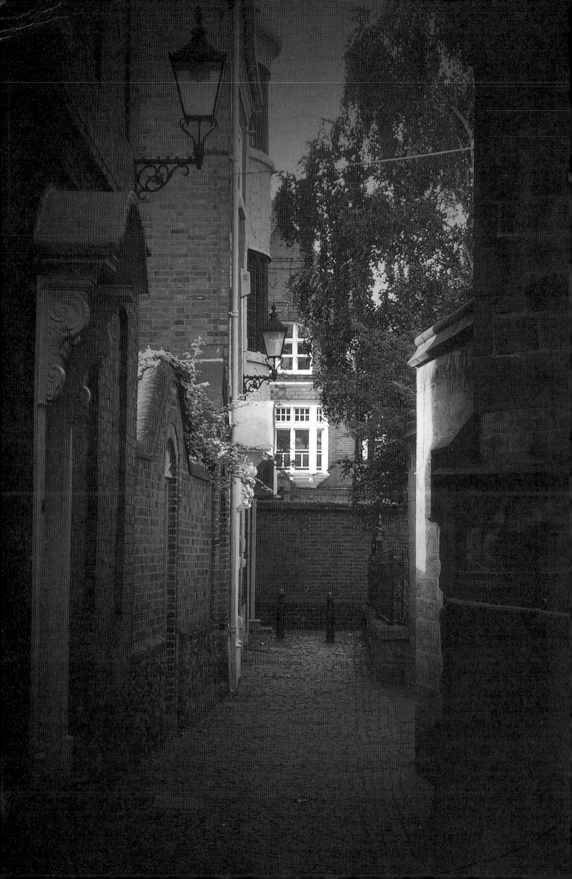